Life along the Illinois River

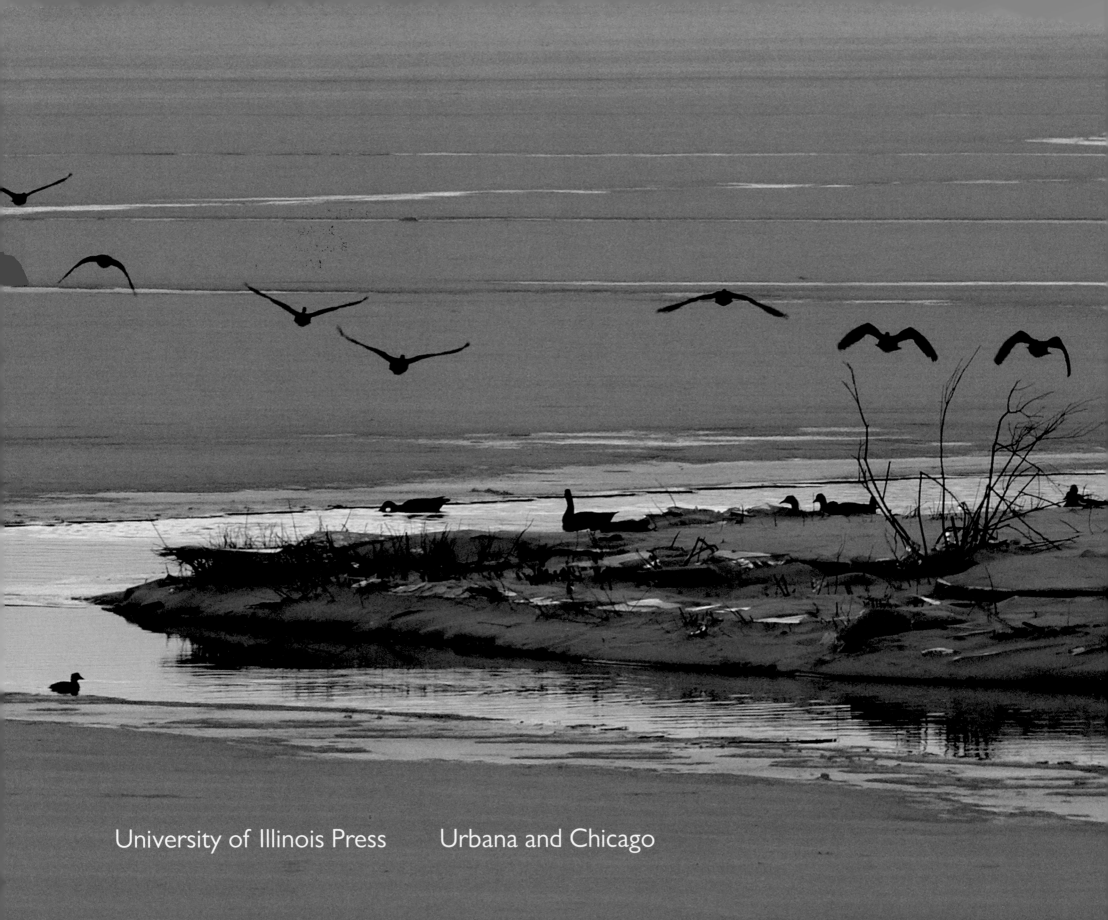

University of Illinois Press Urbana and Chicago

LIFE ALONG THE Illinois River

Photographs
and Introduction by

David Zalaznik

Foreword by Pat Quinn

Library of Congress Cataloging-in-Publication Data
Zalaznik, David.
Life along the Illinois River / photographs and
introduction by David Zalaznik ; foreword by Pat Quinn.
p. cm.
ISBN 978-0-252-03393-3 (cloth : alk. paper)
1. Illinois River (Ill.)—Pictorial works.
2. Illinois River Region (Ill.)—Pictorial works.
3. River life—Illinois—Illinois River—Pictorial works.
I. Title.
F547.I2Z35 2009
977.3'50440222—dc22 2008006959

For my parents, Vic and Eunice Zalaznik,
and for Clare, who every day teaches
by example the importance
of experiencing life.

Illinois is defined, both historically and geographically, by its waters. Our state boundaries follow the channels of the Mississippi River, the Ohio River, and the Wabash River, and our largest city rises on the shores of Lake Michigan.

Then there is our namesake river, the Illinois, flowing with its tributaries through the heart of our state, linking the great rivers of the American West with the Great Lakes, the St. Lawrence Seaway, and ultimately, the wide Atlantic Ocean.

Since the very beginning of our state's history, the Illinois River has brought life to our communities, our economy, and our people. Native Americans settled, hunted, and fished on the riverbanks, building great civilizations that are memorialized in Dixon Mounds and Cahokia Mounds. In 1673, the French Canadian voyageurs Louis Joliet and Father Jacques Marquette canoed from the Mississippi River up along the Illinois to its tributary, the Des Plaines, then portaged two miles to the Chicago River and its mouth at the wide banks of Lake Michigan. Their vision of a channel connecting the Great Lakes to the Illinois River, and ultimately to the Gulf of Mexico, became reality nearly two centuries later with the Illinois and Michigan Canal.

By that time, European settlers had created new towns and villages throughout the river basin, making their livelihoods from the river's waterfowl, fish, and freshwater mussels. The Illinois River and its backwater lakes were so productive and vibrant with life that they supported one of the world's largest freshwater fisheries. Steamboats churned up and down the river, connecting Illinois and its people with markets throughout the United States and around the world.

Abraham Lincoln spent his young adulthood by the waters of the Illinois River Valley, first sharing a homestead with his parents on the banks of the Sangamon River,

Foreword

Pat Quinn

ILLINOIS
LIEUTENANT GOVERNOR

then striking off on his own by canoe to homestead in New Salem. In 1831, the young Lincoln and a couple of adventuresome friends built a flatboat and floated down the Sangamon River to the Illinois River, then followed the Mississippi River all the way to New Orleans.

But as the nineteenth century came to a close, the river that had brought prosperity to so many began to suffer from human thoughtlessness. Industrial pollution fouled the waters of the Illinois River, and silt from sprawling farmlands clogged the river channels. New cities and their inhabitants increased the demand for water from the once-majestic river.

As the river waters grew shallower and dirtier, the river ecosystem dwindled. "Wash days" in urban areas sent masses of gray phosphorous-filled suds floating downstream, while littered garbage and other wastes left the rivers and their banks odorous and unsightly.

Then the federal Clean Water Act of 1972 was passed, providing much-needed regulation of industrial pollution sources and beginning a slow but spectacular river renaissance. As water quality improved, many species of fish returned, and wetlands that had been barren welcomed renewed growth of native plants.

Thanks to efforts by the State of Illinois, including the creation of the Illinois River Coordinating Council (IRCC), river and uplands habitats have been restored, and fishermen now linger on verdant shorelines. The IRCC's support led to the designation of Illinois River Country as a National Scenic Byway, drawing tourists to the scenic floodplain. Through the Dickson Mounds Museum, visitors can travel back in time to learn about the pre-Columbian people who lived beside the Illinois River, drawn by the universal, timeless human needs for water, food, transportation, and recreation.

Today, the Nature Conservancy's Emiquon and Spunky Bottoms projects have renewed the beauty and health of the Illinois River floodplain and highlighted the enormous resiliency of nature. The innovative Mud to Parks program, supported by my own office, excavates and reclaims tons of silt clogging the Illinois River to provide rich topsoil for abandoned industrial sites and landfills.

As the remarkable photographs in this book so clearly illustrate, the Illinois River valley has enjoyed a spectacular comeback. I hope you will enjoy this book—and more important, I hope it will inspire you to come and explore the rich cultural heritage and great natural beauty of Illinois River Country.

It is February. The temperature has barely made it to double digits for some time. Rusty Edwards, towboat pilot for a river service out of Lacon, studies his situation from high in the pilothouse.

As far as he can see upriver and down, the Illinois River is frozen from bank to bank. In only a few dozen feet surrounding his boat is there water to be seen, kept open by the pounding of the boat's hull against the ice as Edwards and his deckhand, Bill Beard, try to maneuver a barge loaded with corn into its place on a larger southbound tow.

"This is too dangerous. This could be the last day. I may have to shut it down tomorrow," Edwards says. He knows how hard it is for Beard to work on the icy deck. And the boat itself could suffer severe damage, possibly even sinking, from the constant hammering against thick layers of ice covering the surface of the river. It is a difficult decision. The crew needs to work.

Forty-six river miles north, the same frigid February temperatures bring rejoicing in the canyons. At Starved Rock State Park, a severe drop in the mercury that lasts an extended length of time is infrequent. This is the year.

From all around the Midwest, people have come to the canyons at Starved Rock to stand in line in bitter cold waiting their turn to climb the canyon's frozen waterfalls.

It is summer. Rick Roszell steers his wooden pleasure boat, a Century Resorter, down the Illinois River from the harbor at East Peoria. Pleasure traffic on the river this day is heavy. For Peoria riverfront festivities, such as concerts or the Fourth of July fireworks, dozens of boats will anchor for prime seats. But it is late evening and

Introduction

David Zalaznik

the sun is nearing the horizon. Most of the other boats are gone to slip or trailer. For Roszell, it will be just an hour's ride.

A few miles upriver and a few days earlier, Orion Briney is in his boat, a thirty-foot plate boat. It is 5:30 A.M. and the sun is reaching the horizon. As the sun touches the bluff, a warm glow spreads across Briney's face, and his massive hand twists the throttle to send the boat surging across the river toward the Woodford County shore.

"Yep," Briney says, "we're going to catch some fish today."

And he is right. Big-head Asian carp. Fifteen thousand pounds — 7 ½ tons — by 9 A.M.

This is the Illinois River, which begins at the confluence of the Kankakee and the Des Plaines Rivers in Grundy County. It ends more than 270 river miles south where it joins the Mississippi River at Grafton in Jersey County.

My exploration of the Illinois River began in November 2005 with a telephone message from Sheryl Cohen, a Peoria Art Guild board member, inviting me to be part of an exhibit about the Illinois River. It was an exciting proposal and I did not hesitate to say yes.

In many months and thousands of miles since that telephone call, I have come to recognize the river as a great gift. There are moments when the modulations of the light from night to day or day to night transform the world. There is a setting sun in April that ignites the water's surface with colors of fire, and a great blue heron flies into the camera's frame, dipping its wings into the inferno of color and light. On a dark morning in the skies over Grafton, after one of the coldest nights of the year, a brightly shining half moon suddenly forms a backdrop to waves of Canada geese on wings bearing just a hint of light from the sun still hidden below the eastern horizon.

These are fleeting scenes. They pass in seconds, visible to us all but virtually unobserved. We can live on or near the river for a lifetime and never notice these moments. But we can train our eyes to see them and transform our vision of the world and our place in it.

LIFE
ALONG THE Illinois River

A silver Asian carp leaps from the Illinois River as commercial fisherman Orion Briney steers his thirty-foot plate boat north of Henry. Silver carp are known for flying out of the water, striking boaters and causing injuries. Briney herds carp "like cows" after stringing eight hundred yards of trammel net. He is after big-head Asian carp, which yield more meat than silver carp.

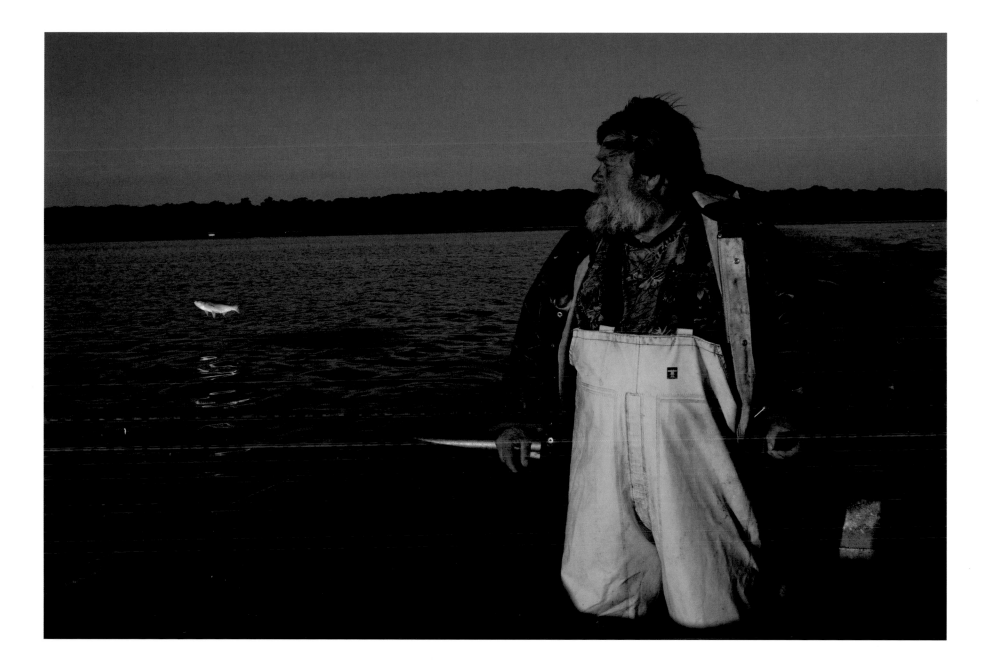

Greg and Denise McKinnon speed across the Illinois River in search of mussels. The husband and wife from Mount Sterling were part of an experiment to reinstate mussel harvesting on the Illinois River, banned in 1994 when invasive zebra mussels were thought to be a threat to native mussels.

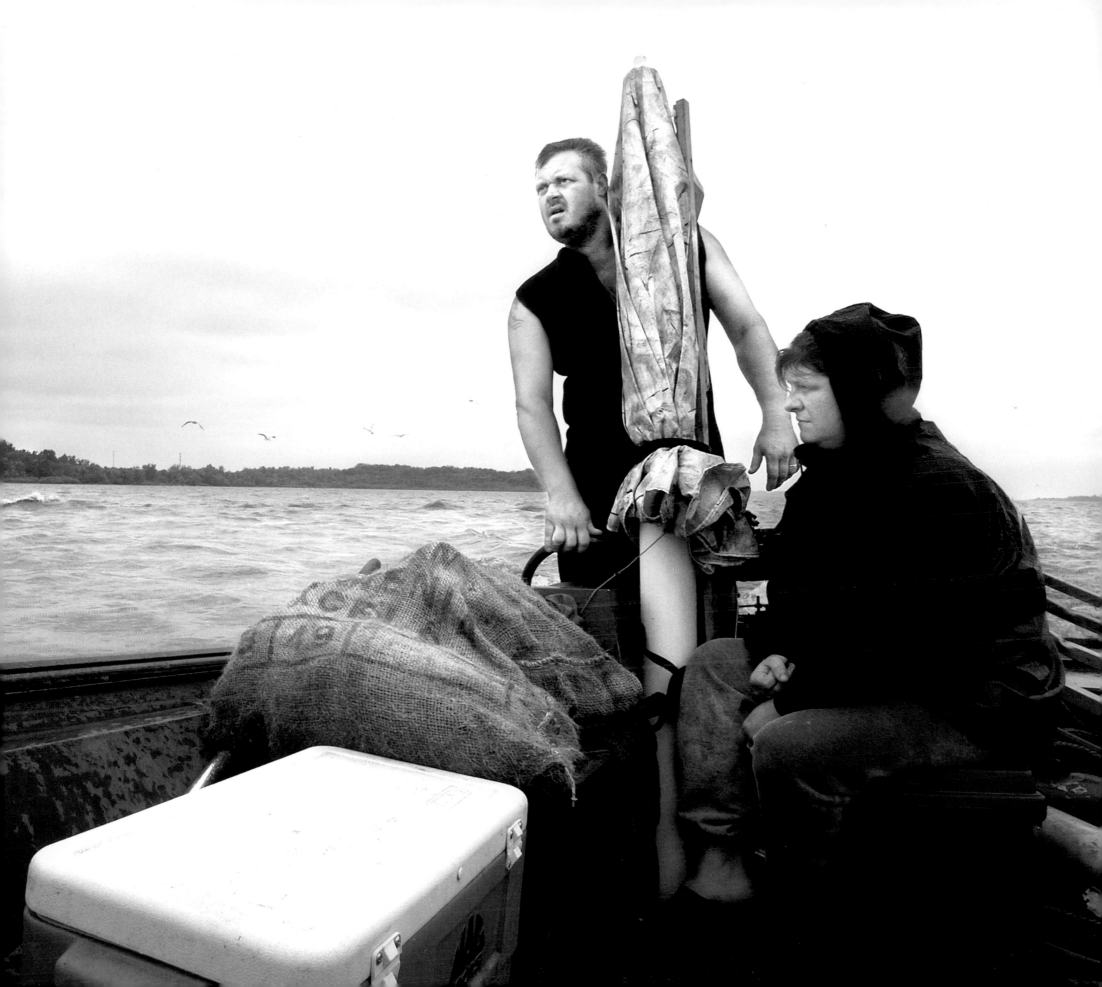

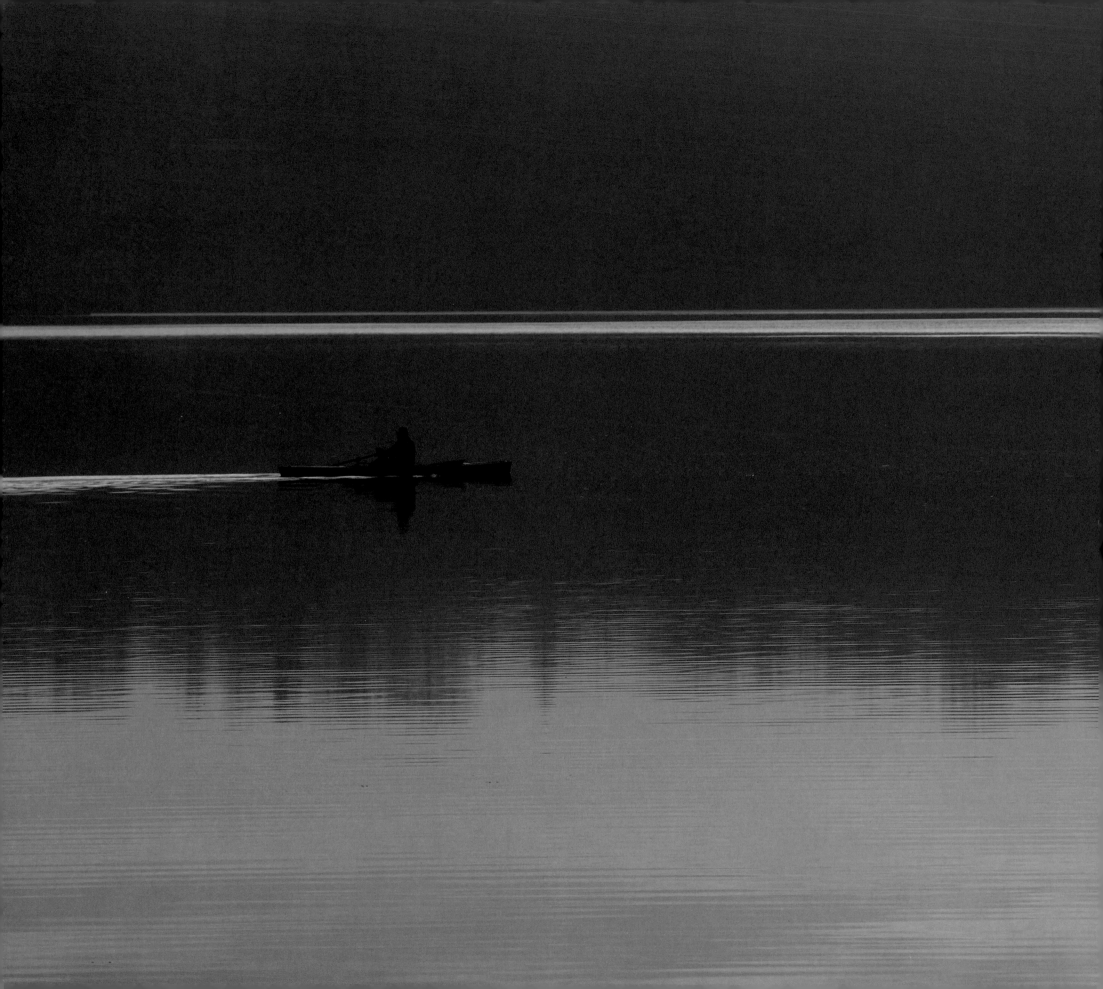

Light bathes a rower at dawn
on the Illinois River.

Steven Antonacci rows his kayak across the jagged frozen surface of the water toward his riverside home near Chillicothe. Antonacci had kayaked to smoother ice on the Woodford County side of the river to ice skate on a frigid February afternoon.

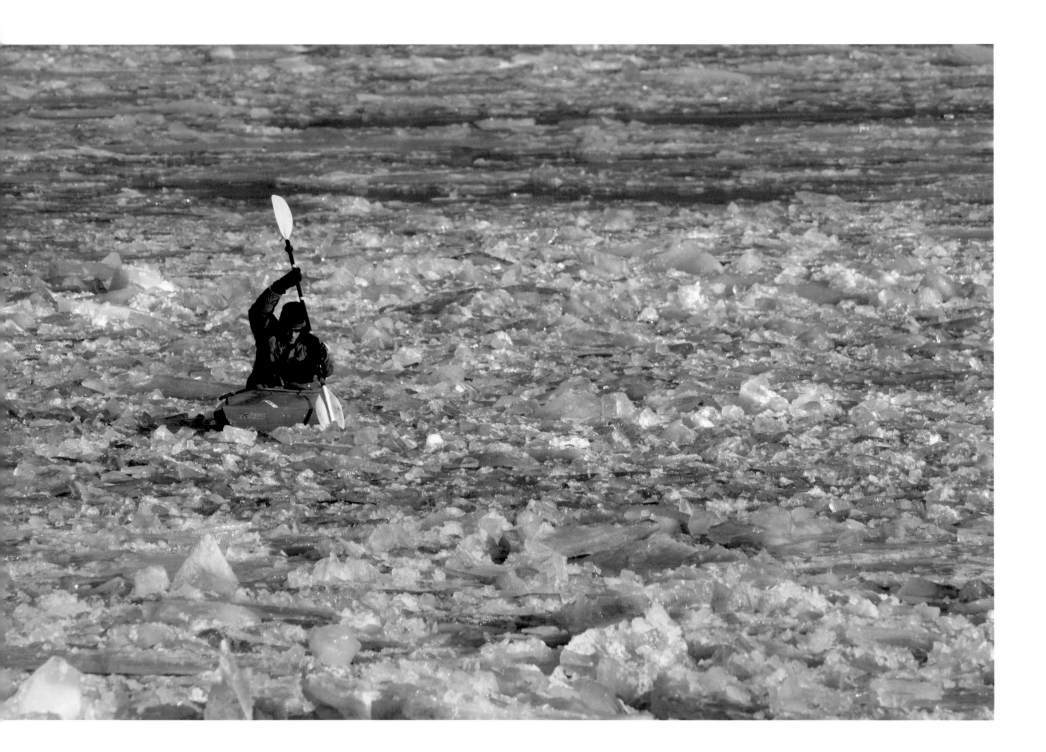

Bath, Illinois.

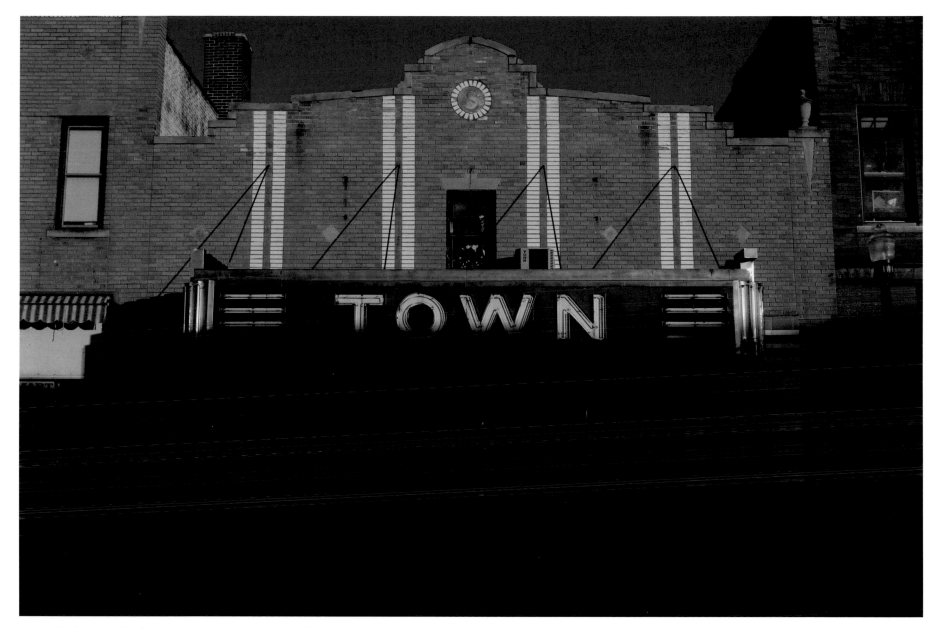

A shadow cast by the rising sun creeps across the façade of the Town Theater in downtown Chillicothe, an old river town.

Clouds over the Illinois River
catch the day's last light.

10

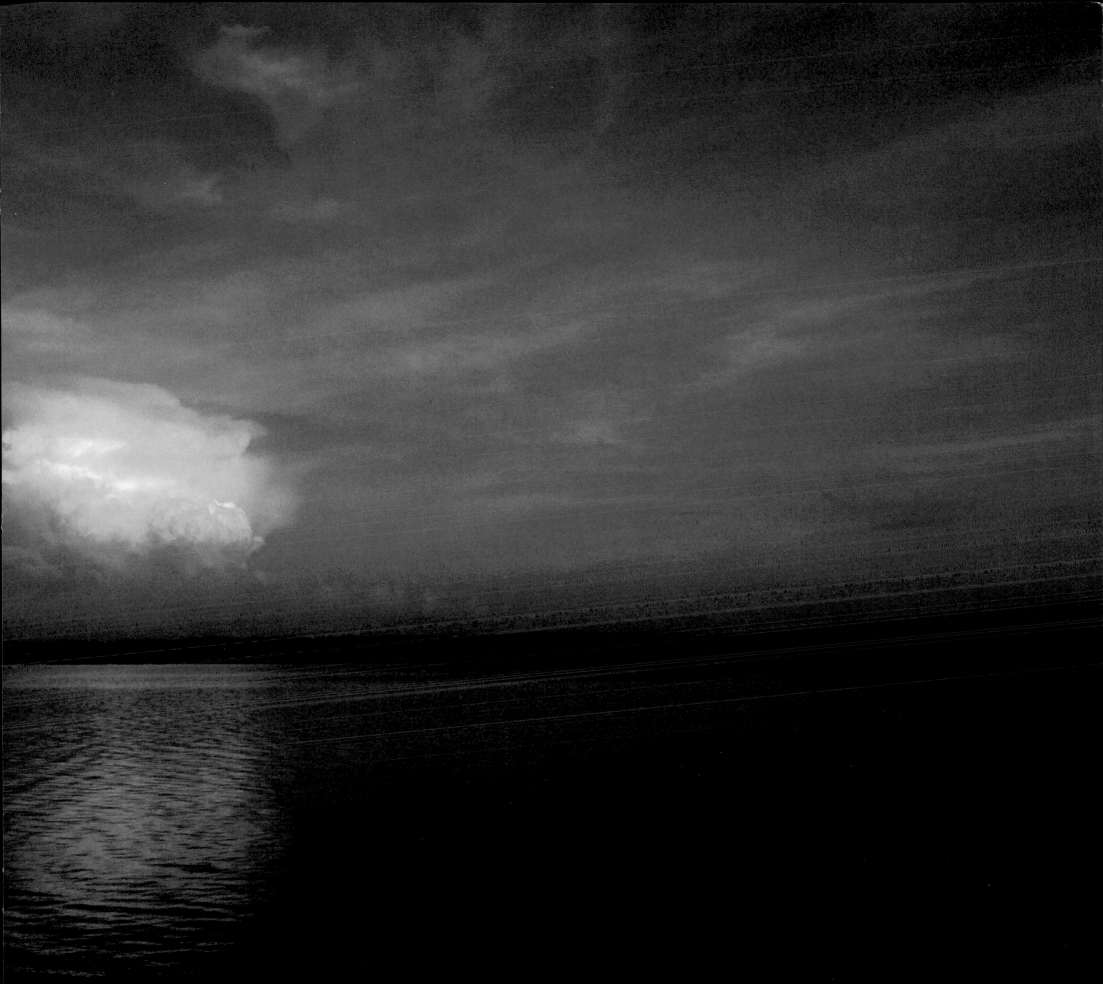

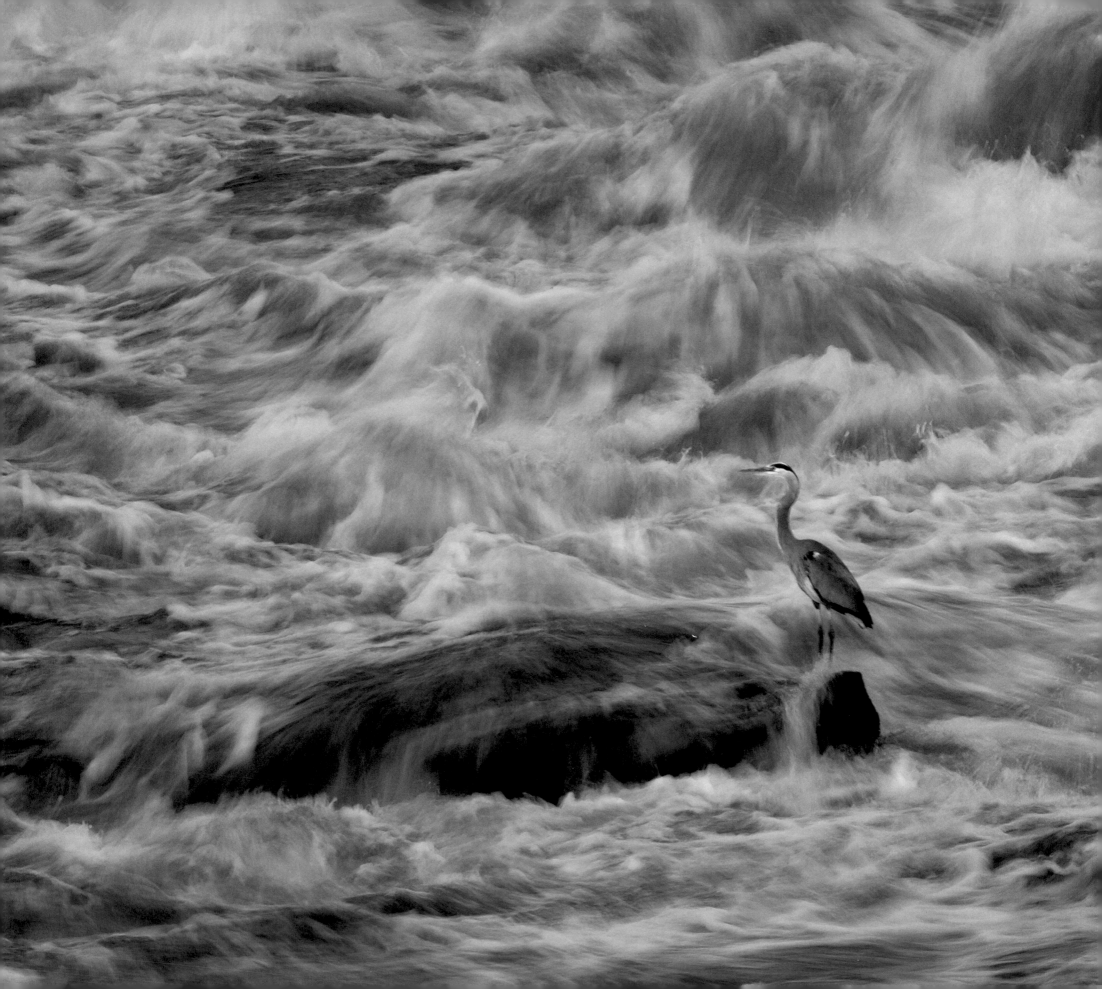

A great blue heron stands motionless searching
for fish in the surging waters below the
Marseilles Lock and Dam.

13

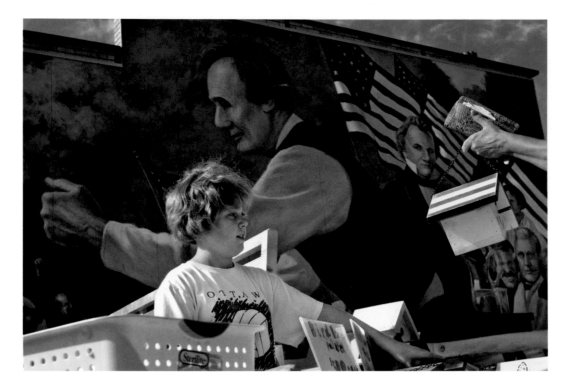

Emily Hackler, 11, completes the sale of one of her handmade birdhouses while operating a booth at the Ottawa Farmers Market. Behind her, Abe Lincoln gestures to a crowd on one of dozens of murals in the La Salle County community. Emily lives on a fourteen-acre farm with her mother and father and sixteen animals, including cows, goats, rabbits, three dogs, and a cat.

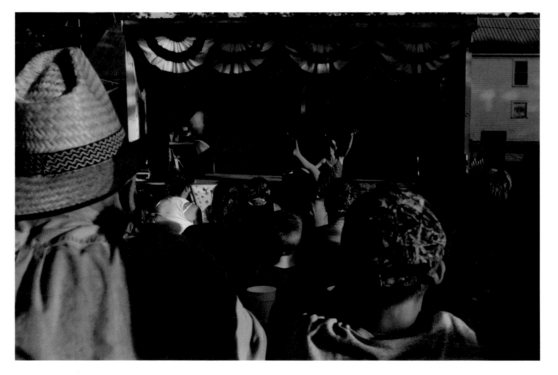

Samantha Halsey, 13, dances a routine at the Fourth of July Blast holiday celebration in the riverside community of Kampsville.

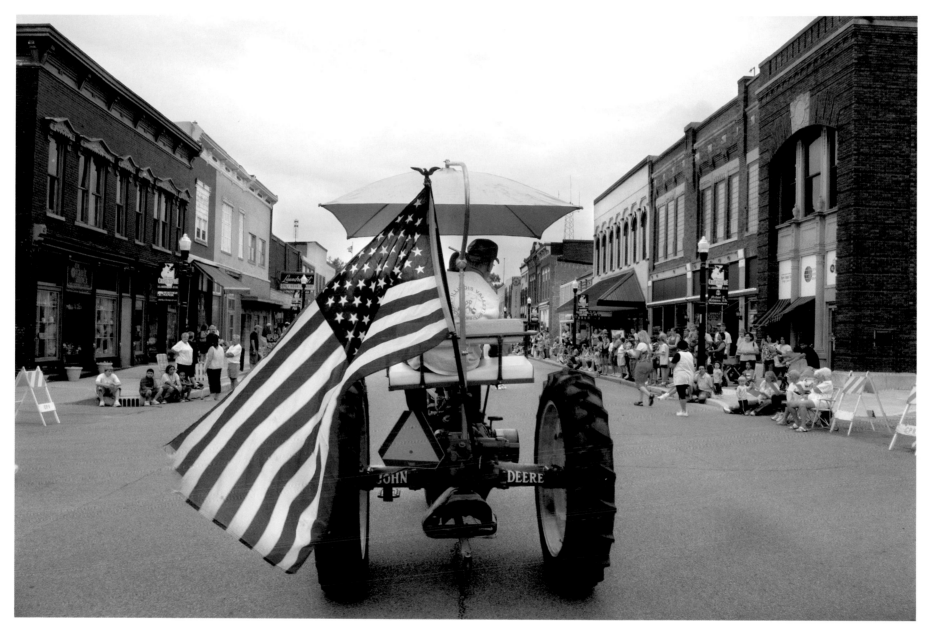

A patriotic tractor makes its way in the Claud-Elen Days parade
in downtown Chillicothe.

A great blue heron glides above the
surface of the Illinois River near Lacon.

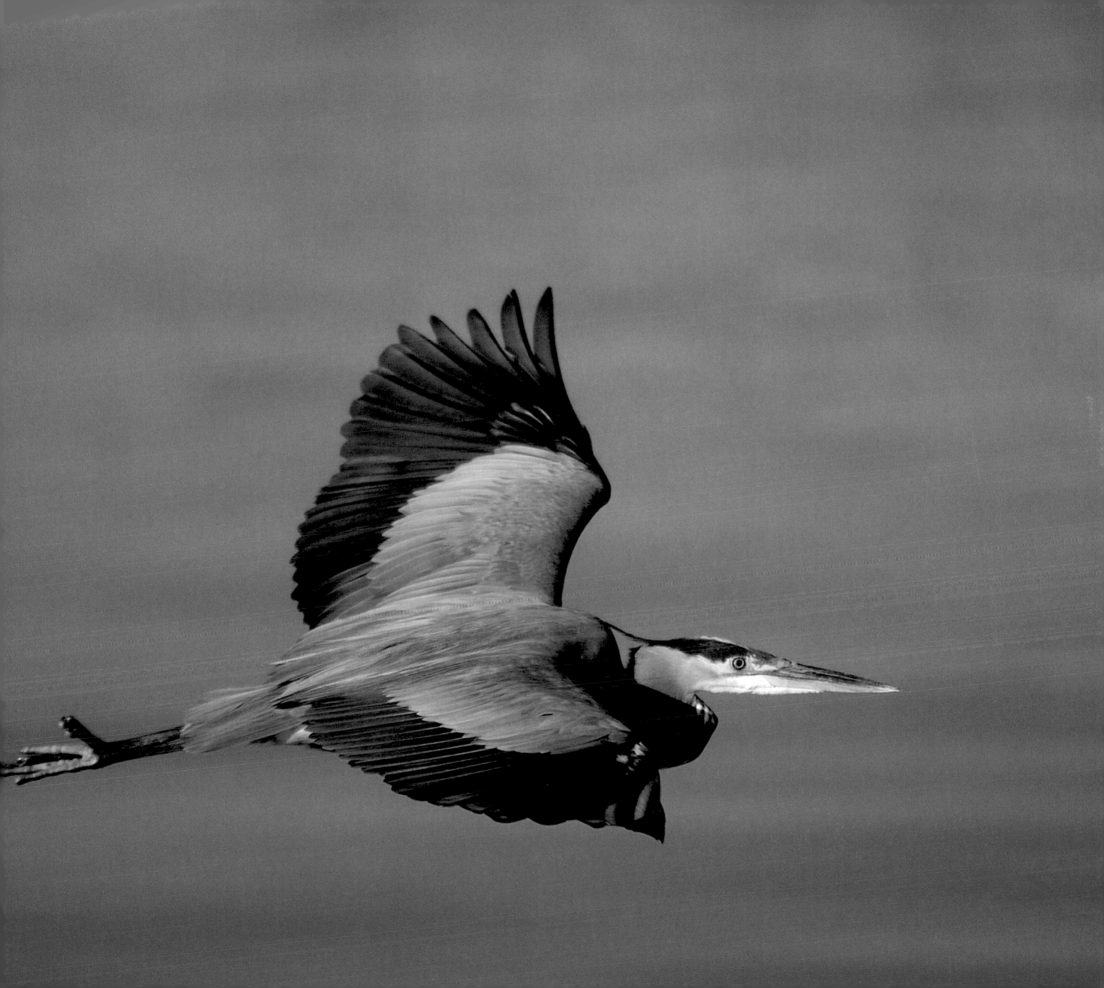

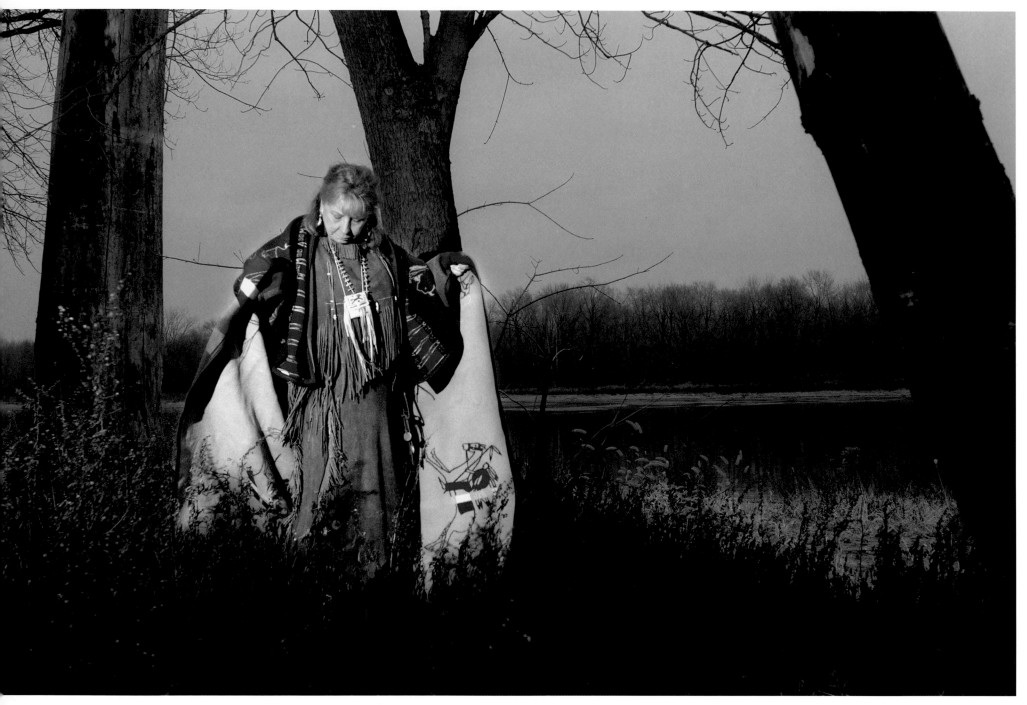

Eliida Lakota walks along the banks of the Illinois River wearing a native dress she made. She finds the river helps her forge a spiritual bond with her Native American ancestors. Lakota is an artist, teacher, and occupational therapist who also teaches a class in Native American spirituality.

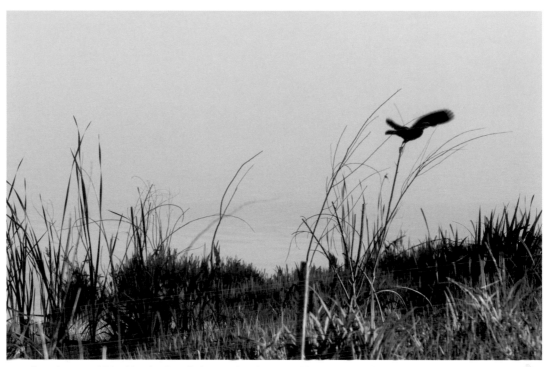

A red-winged blackbird takes flight on the shore at Hennepin and
Hopper Lakes, site of a Wetlands Initiative restoration that began
in 2001 on land leveed and drained for farming in the early 1900s.

Asian carp leaping from the Illinois
River are now quarry for fishermen
who have traded rods and reels for
bows and arrows.

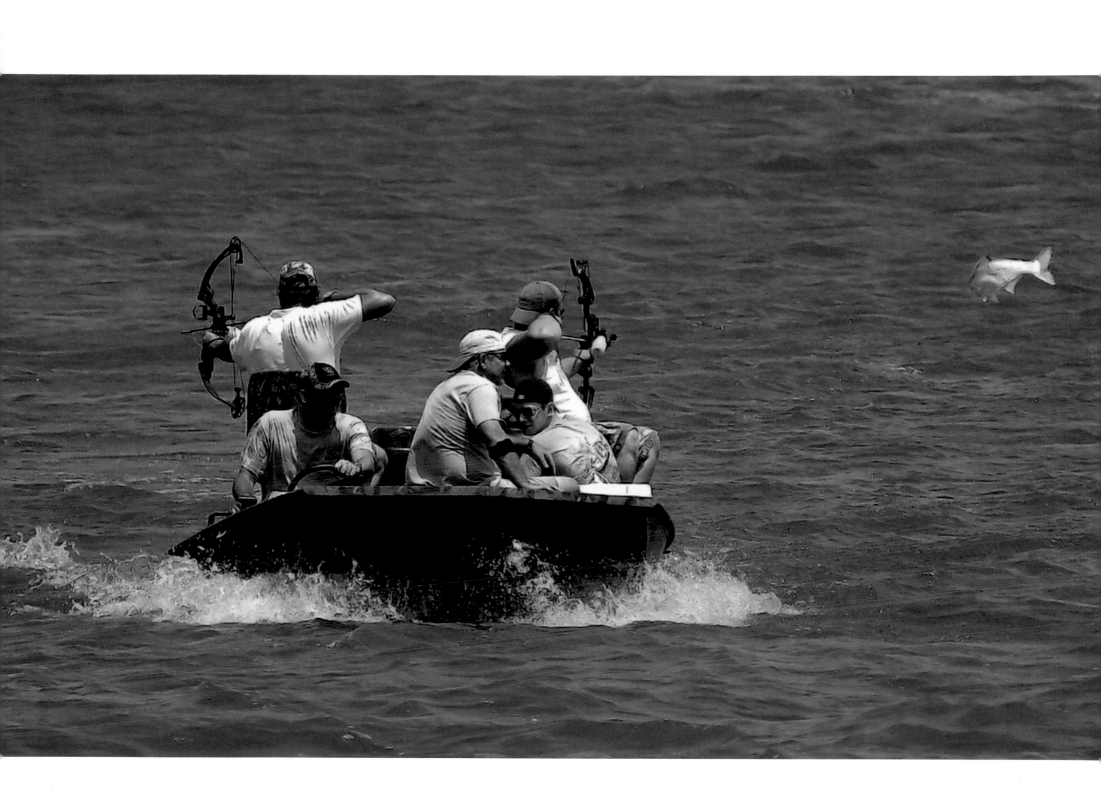

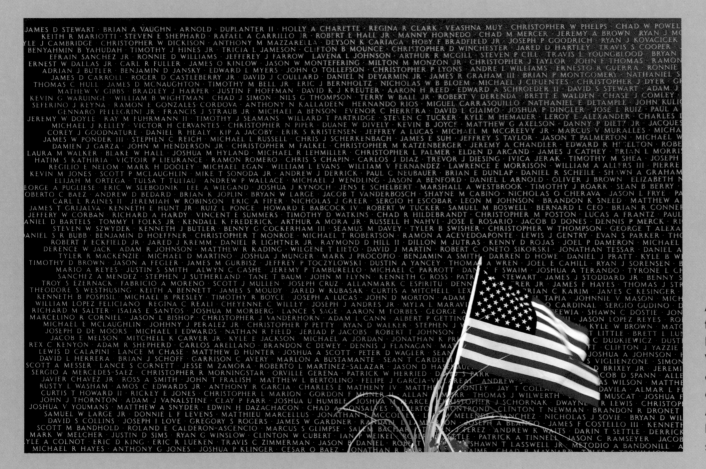

A small flag blows in steady wind from the Illinois River before the Middle East Conflicts Memorial Wall at Marseilles. Thousands of names on the monument, dedicated in 2004, recall American soldiers killed in the line of duty in the Middle East since 1980.

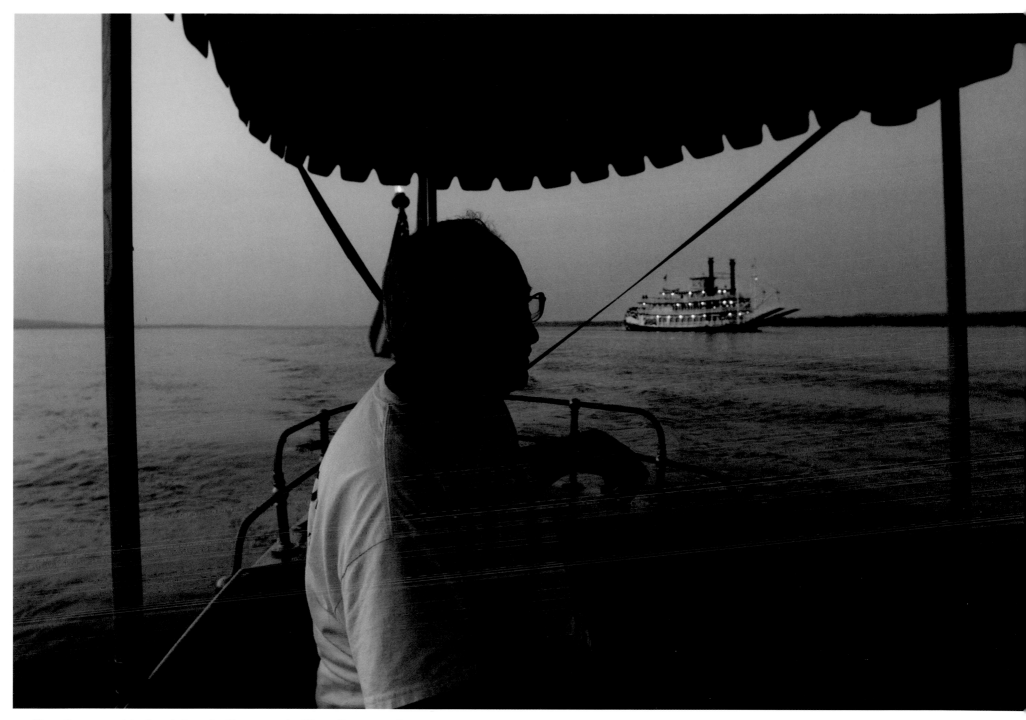

Tom Cox steers his electric launch, *Electra,* on the Illinois River near Peoria as the *Spirit of Peoria* excursion boat approaches in the distance.

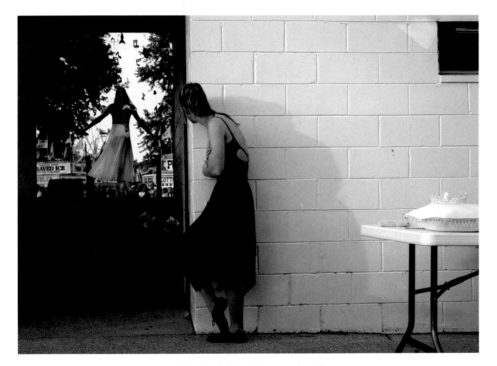

Miss Chillicothe contestant Kayleigh Diveley watches from backstage as Carolyn Rene McCullough performs her ballet routine. The coveted crown rests on a pillow at right.

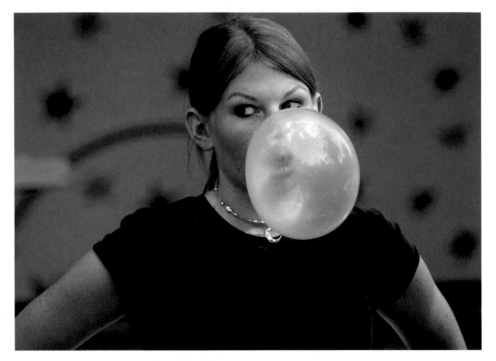

Krista Freeman, 14, of Pittsfield, Illinois, competes in a bubblegum-blowing contest at the Fourth of July Blast in Kampsville.

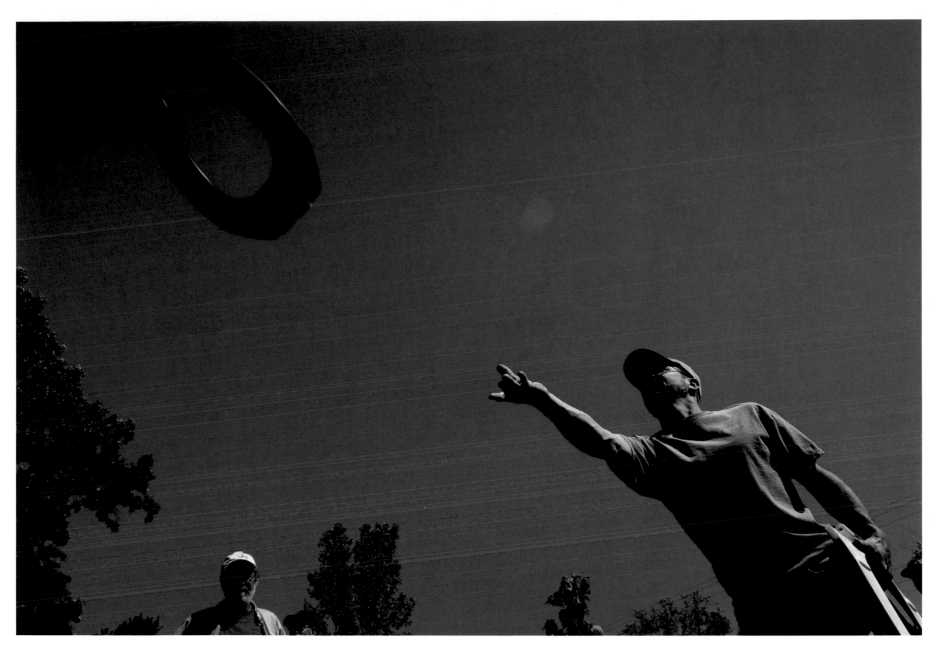

Dan O'Leary, of Defiance, Missouri, lets fly a shot during a game of "toiletshoes," a variation of traditional horseshoes using toilet seats, during festivities at Flood Fest in Grafton, Illinois. The festival began after the devastating 1993 Mississippi River flooding.

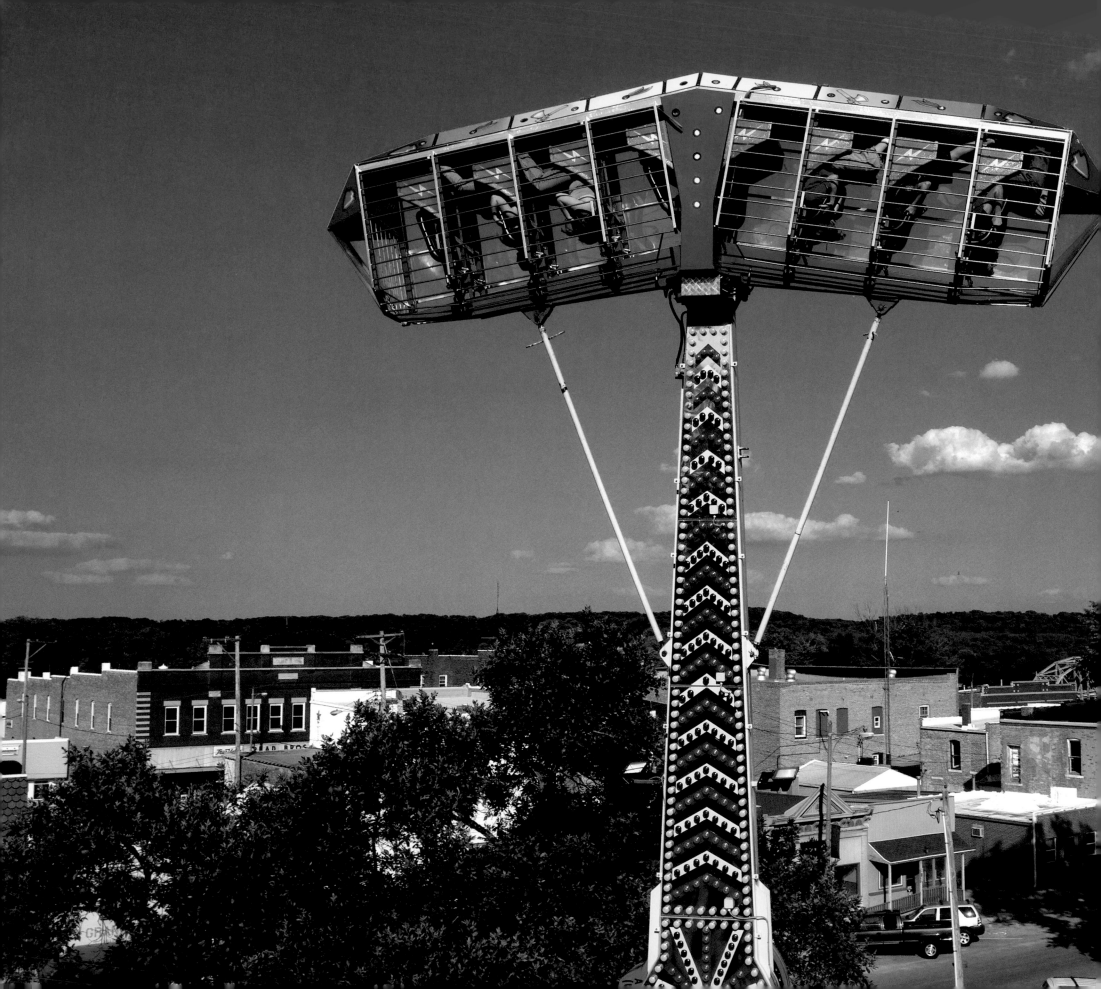

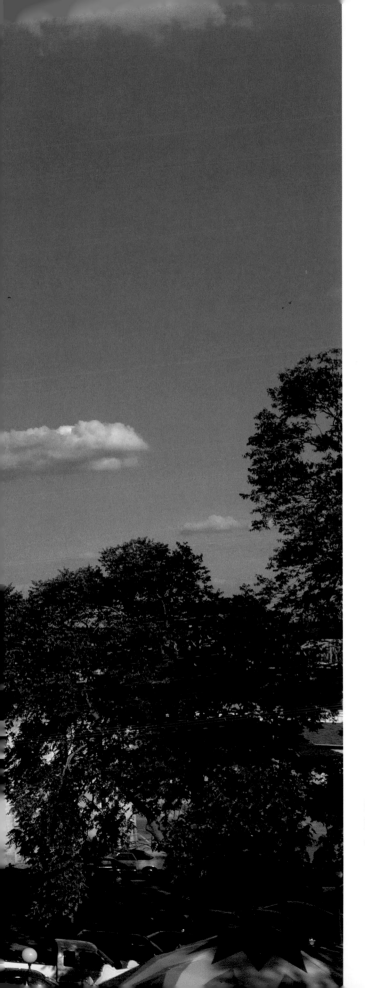

Passengers on a carnival ride in Henry, Illinois, hang suspended over the Marshall County community.

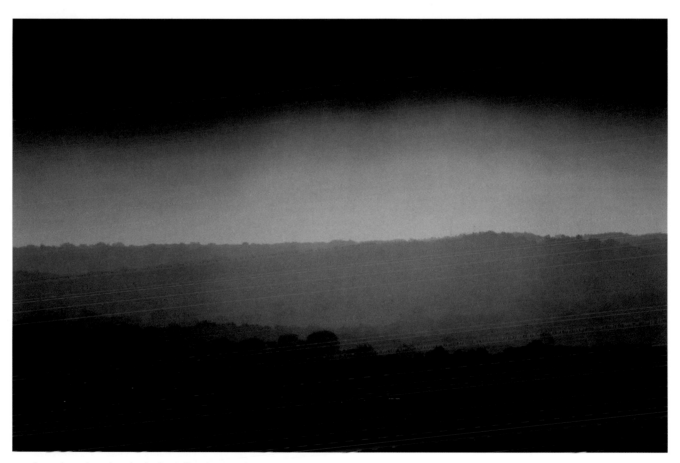

Low-hanging clouds darken the sky at sunrise
as mist settles into Woodford County.

Geese are silhouetted against light
pouring through an opening in a
cloud bank in the western sky over
an Illinois River wetland at day's end.

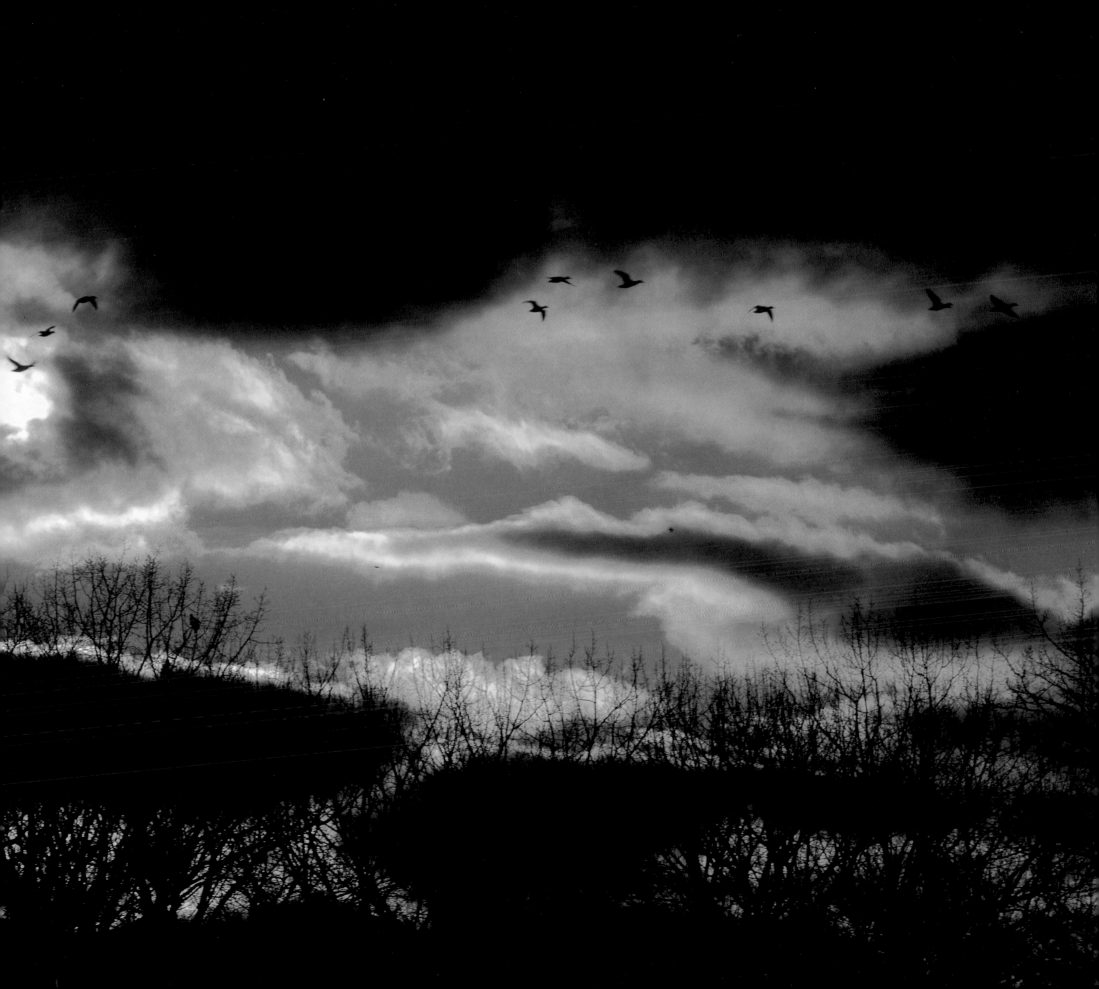

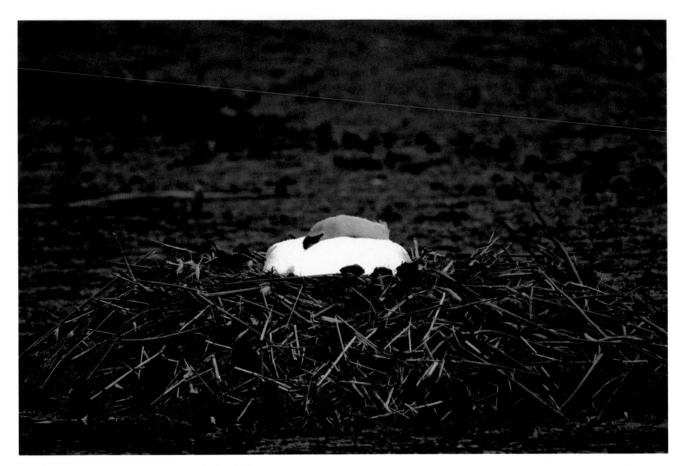

A mute swan sits on a nest at Spring Lake
Fish and Wildlife Area in Tazewell County.
The wildlife area covers more than two
thousand acres.

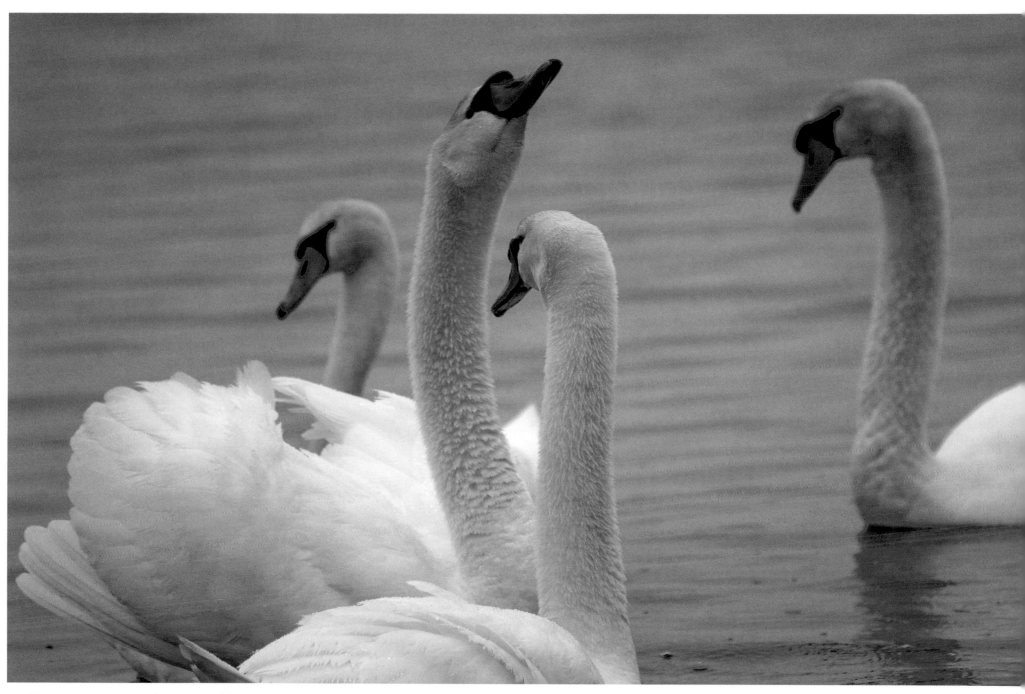

Mute swans gather on the waters of Spring Lake
Fish and Wildlife Area.

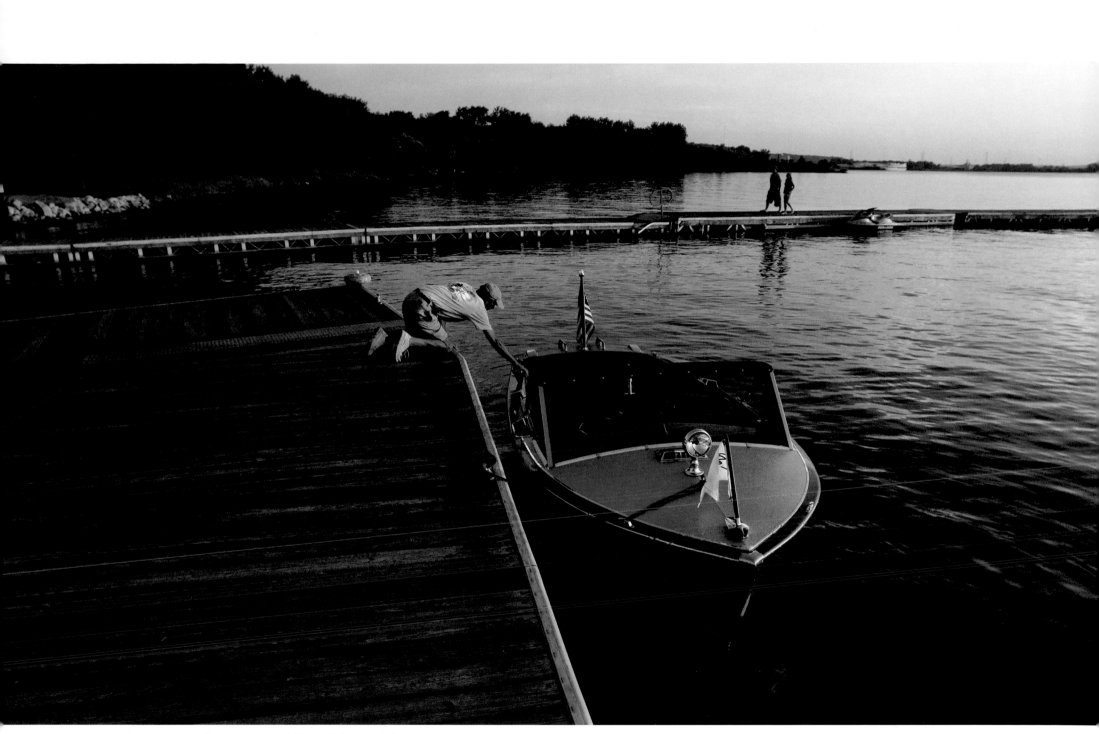

As the sun meets the horizon, Rick Roszell ties up his boat.

Rick Roszell steers his Century
Resorter for an evening ride on
the Illinois River near Peoria.

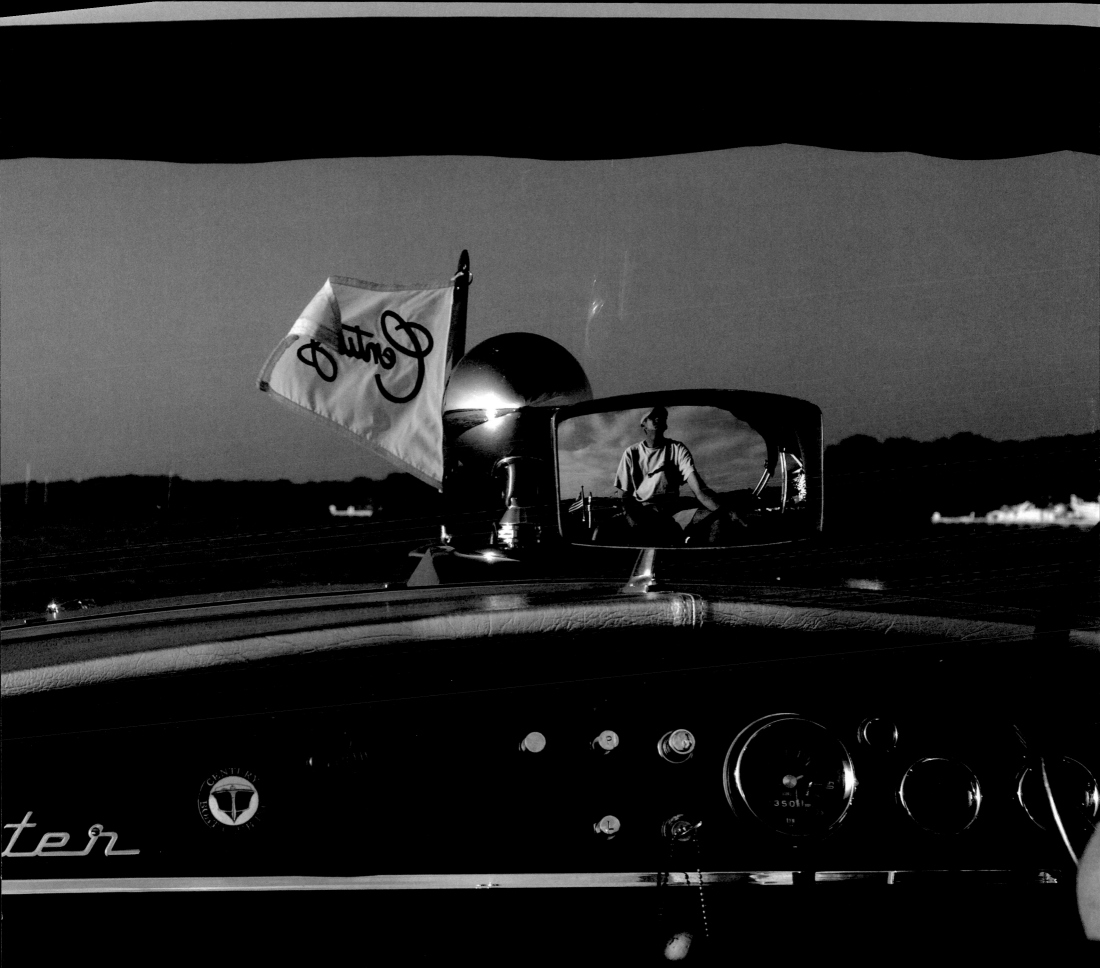

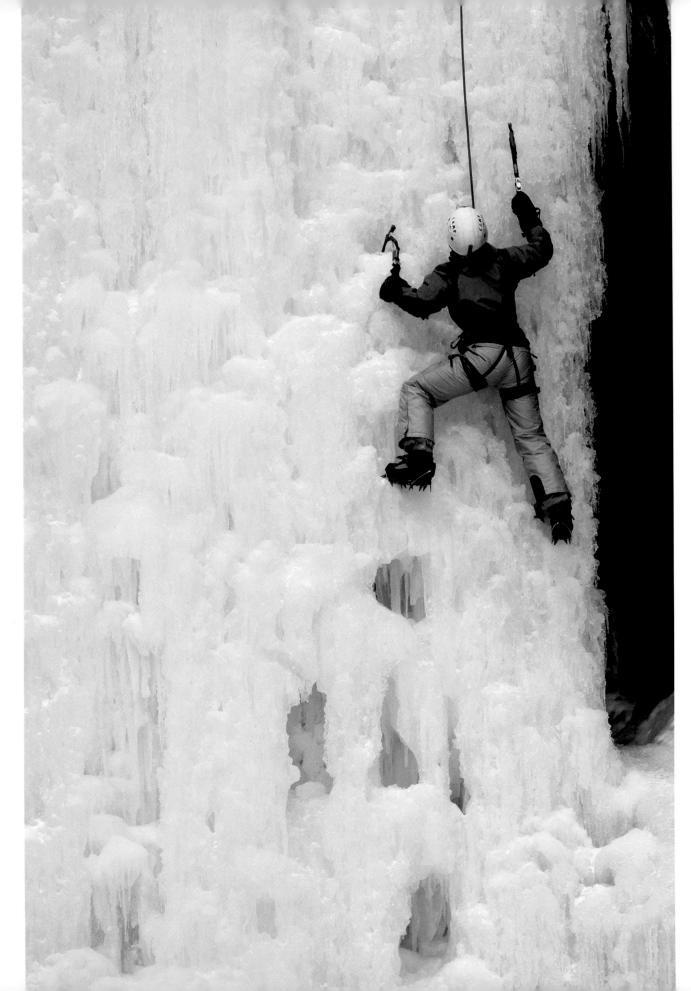

Petra Havlickova of Villa Park, Illinois, makes her way up a frozen waterfall in Wildcat Canyon.

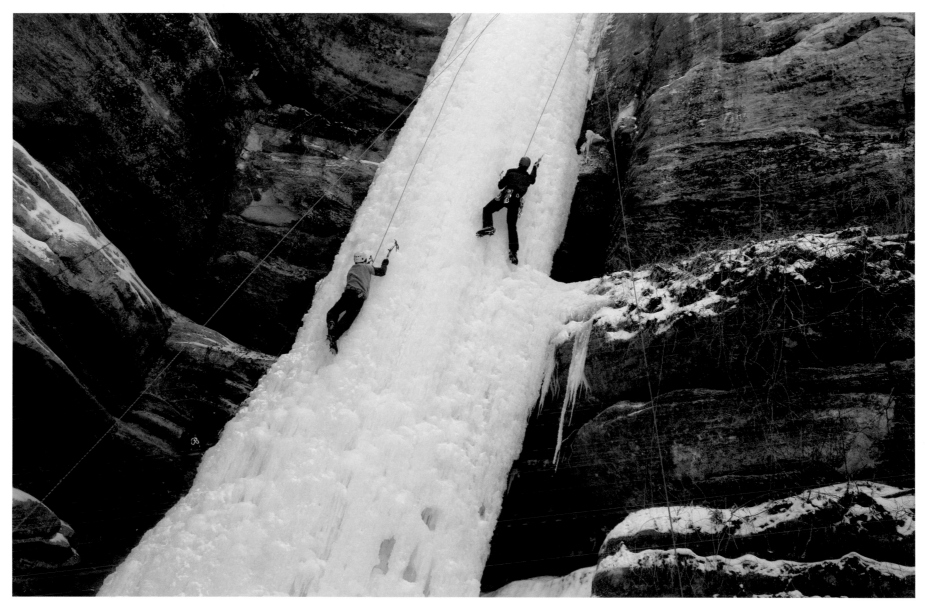

Climbers scale frozen waterfalls in Wildcat Canyon at Starved Rock State Park. Temperatures are seldom low enough for an extended period of time to ensure safe climbing. When conditions are right, ice climbers travel from throughout the Midwest for a chance to ascend the falls.

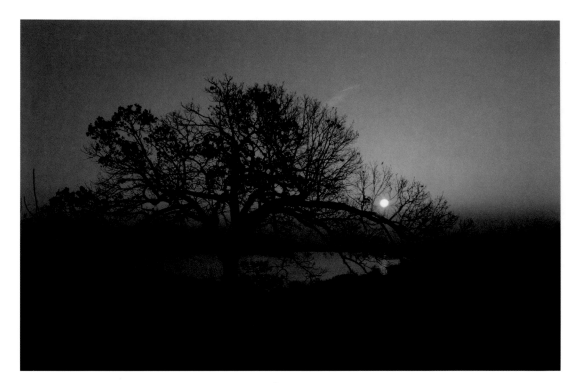

An oak tree on Peoria's Grandview Drive traces a pattern against the rising sun.

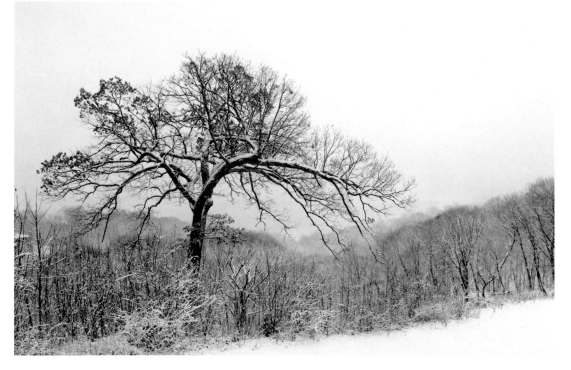

The Grandview Drive oak in winter.

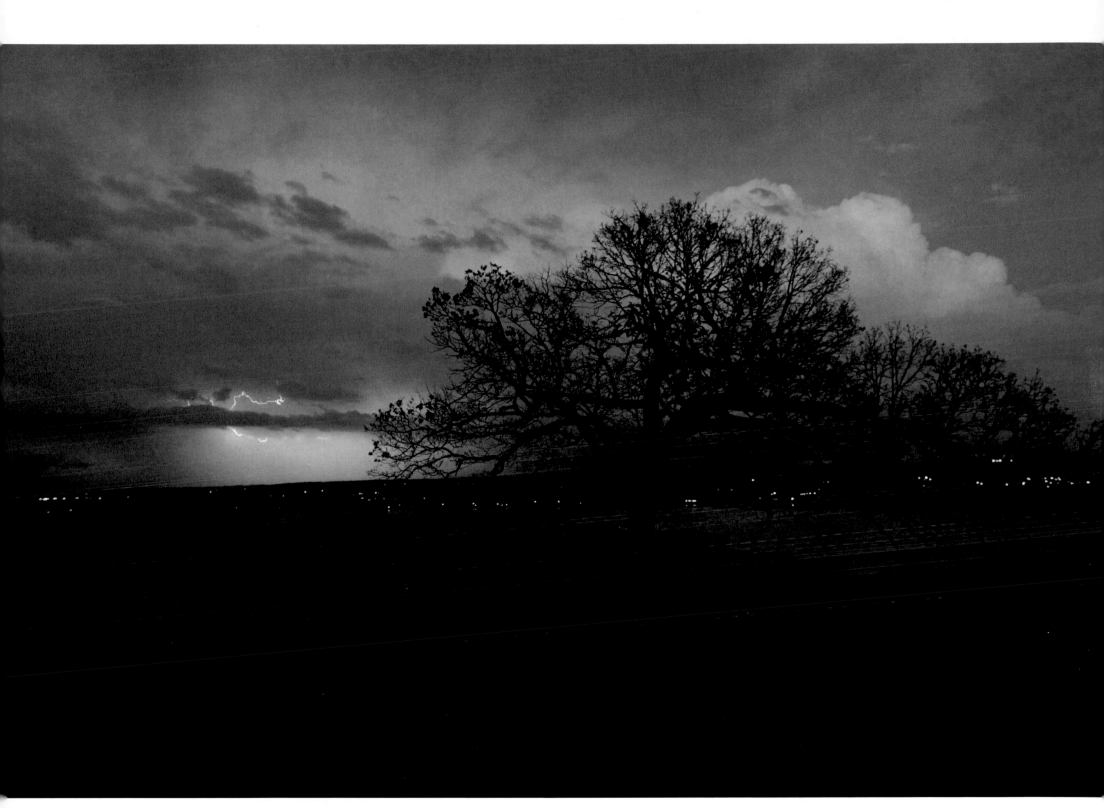

Lightning crackles in the sky behind the oak on Grandview Drive.

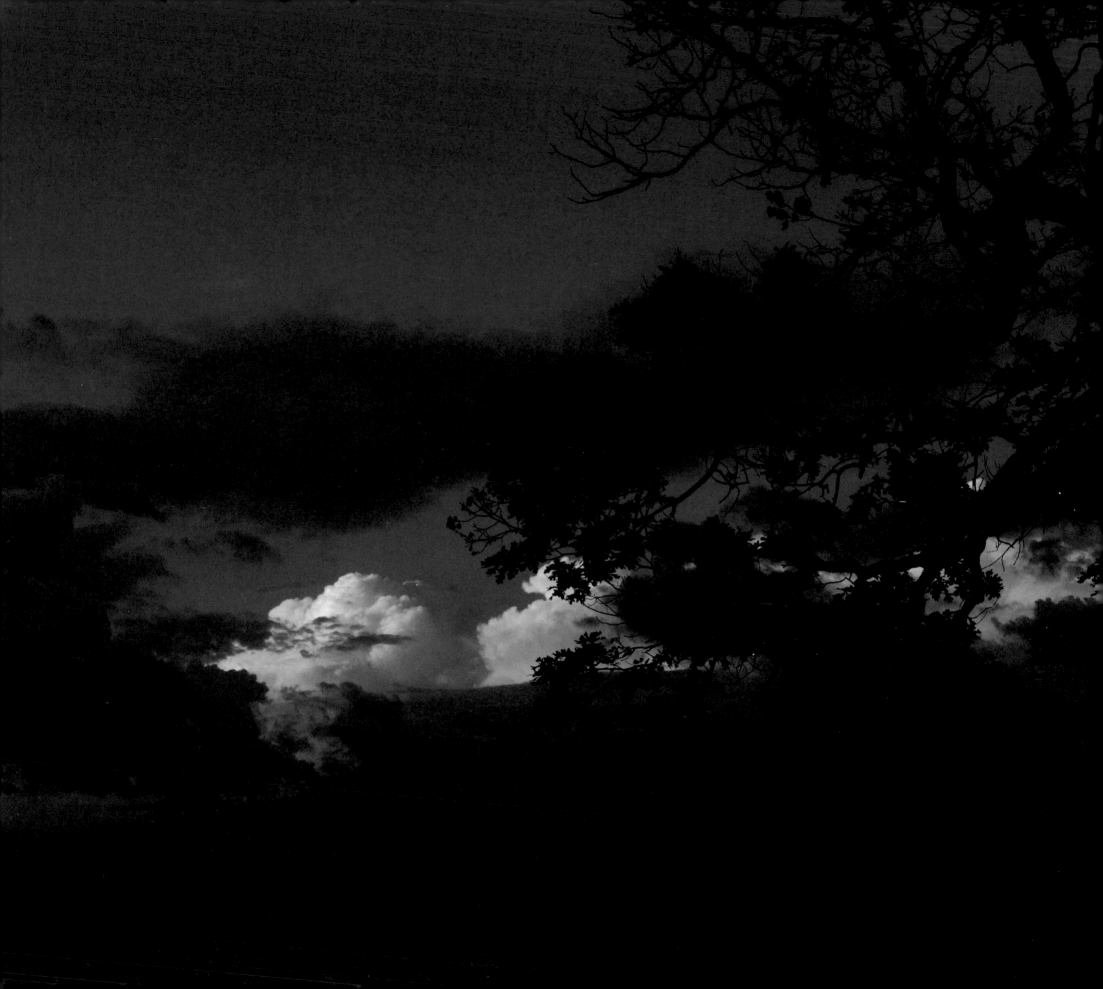

Clouds catch the last rays of
the setting sun as backdrop to
the Grandview Drive oak.

A great blue heron dips low over the
Illinois River, ablaze in orange as the sun
sets behind Peoria's skyline.

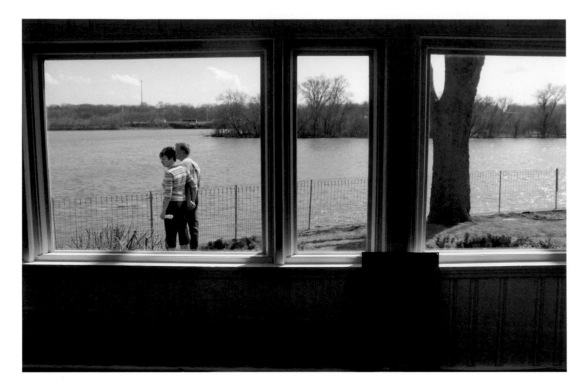

A vintage sign beckons as Christine K. Martin and David Koster walk the grounds of a house for sale overlooking the Illinois River in Ottawa.

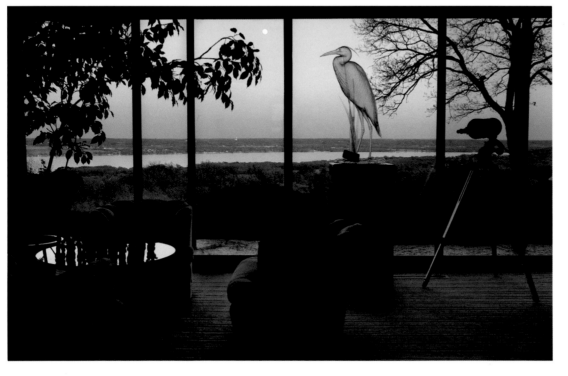

A full moon rises over the Illinois River valley viewed from the living room of Peoria artist George Ann Danehower and her husband, Chester Danehower.

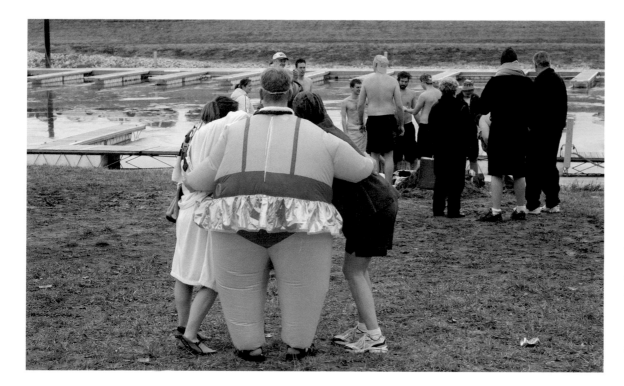

A man wearing an inflatable costume poses for a photograph following his plunge into the cold waters of the Illinois River on New Year's Day. The ritual is performed in communities up and down the river to raise money for local charities.

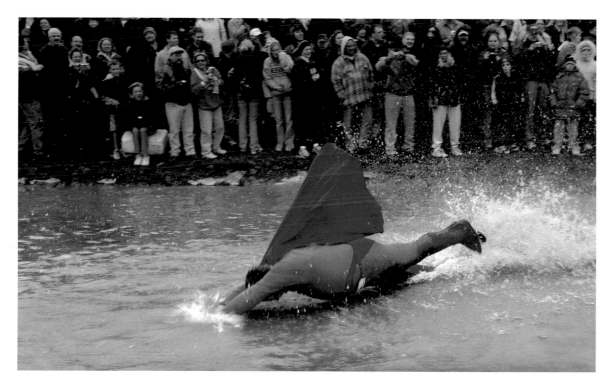

A crowd watching the Polar Ice Plunge in Tazewell County enjoys a super effort by a participant.

North American white pelicans fly
upriver at sunrise as fog envelops
the bluffs of Woodford County.

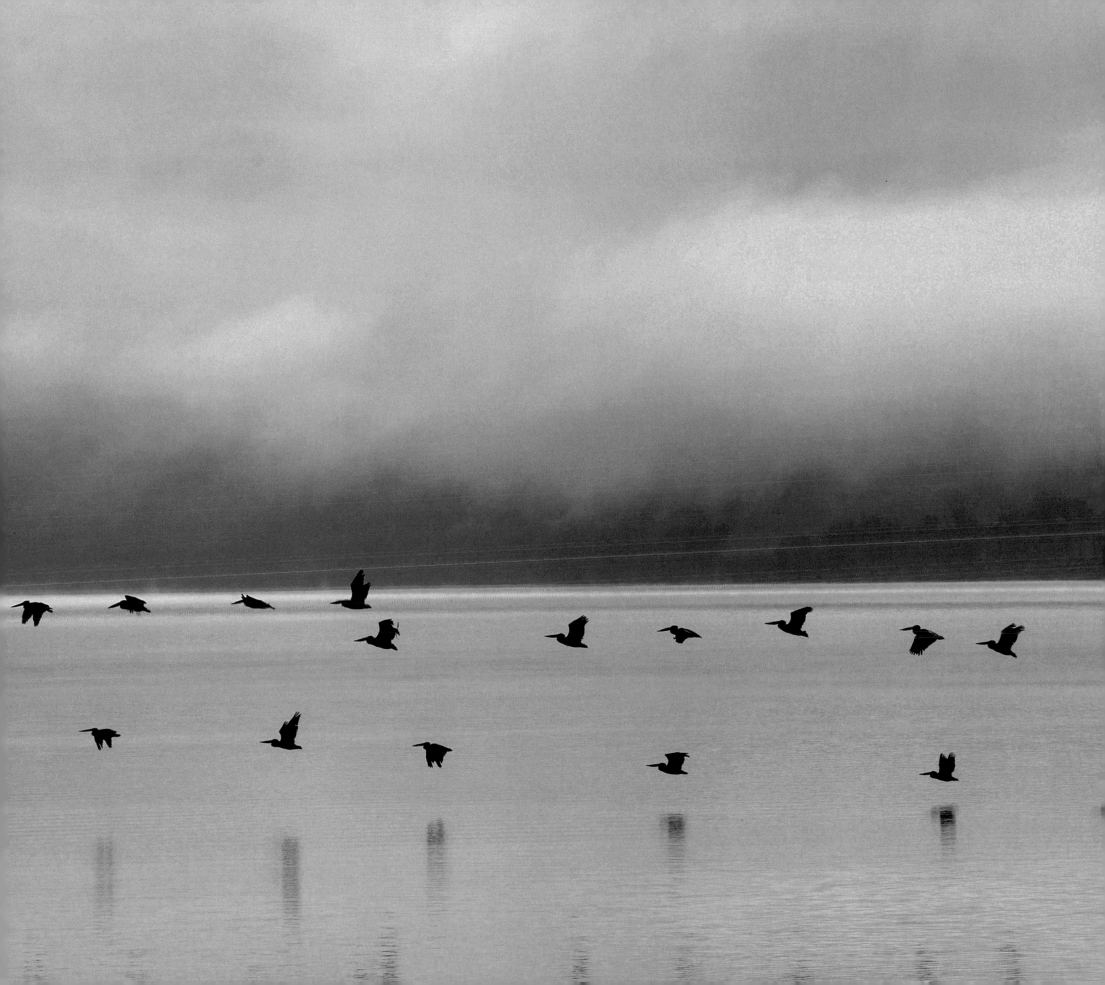

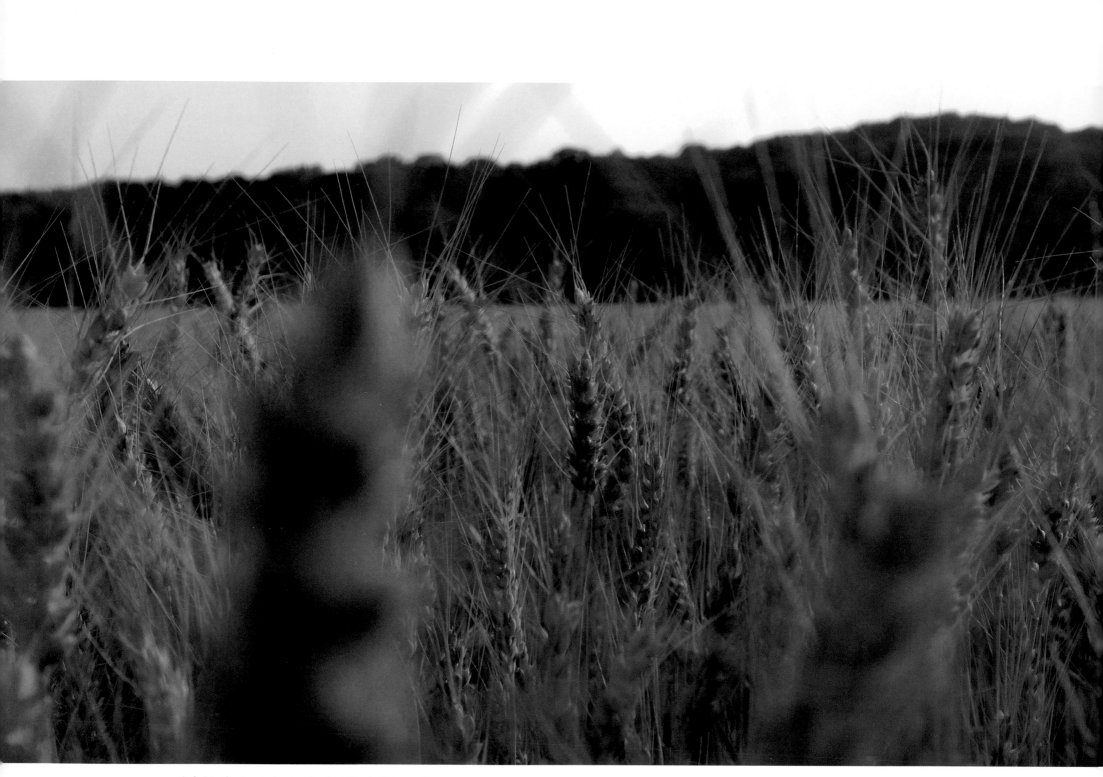

A field of wheat planted in the Illinois River valley
turns golden at sunset.

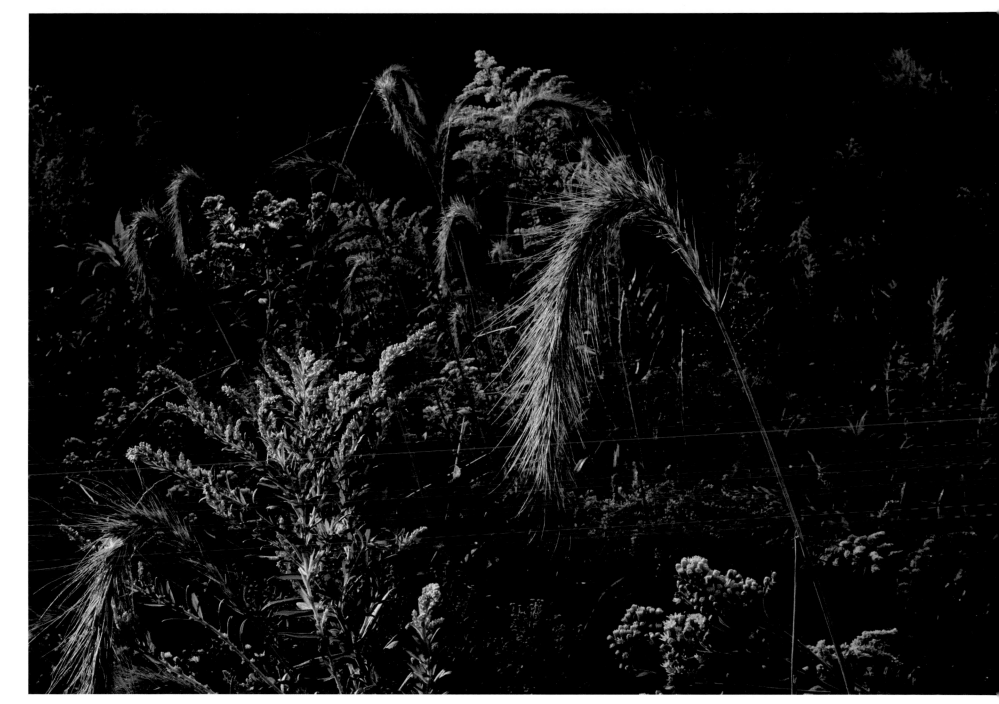

Morning sun highlights grasses at the Sue and Wes Dixon Waterfowl Refuge at
Hennepin and Hopper Lakes, near Hennepin in Putnam County.

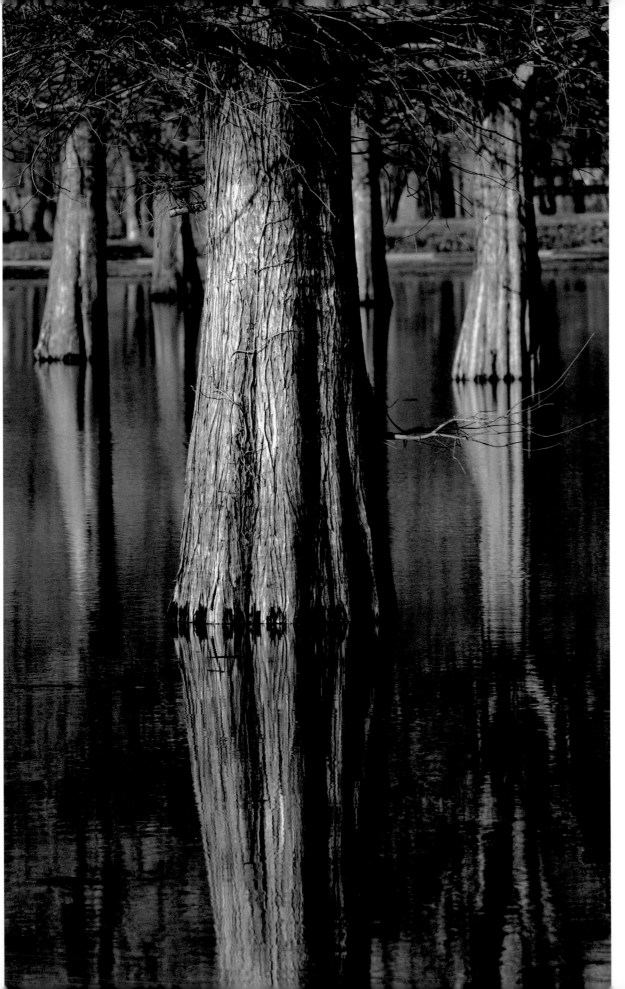

Rising waters of the Illinois River
surround trees at the Woodford
State Fish and Wildlife Area.

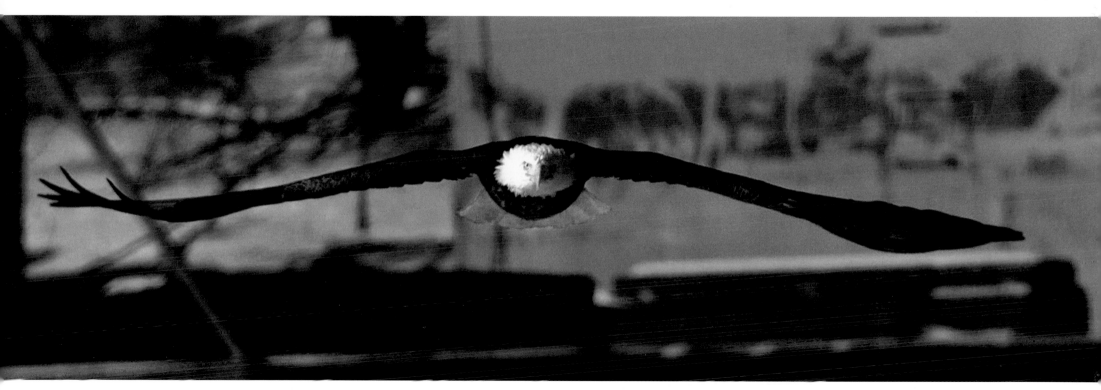

A bald eagle scans for prey on the Illinois River.

The sun rises from behind a cloud layer over the Illinois River.

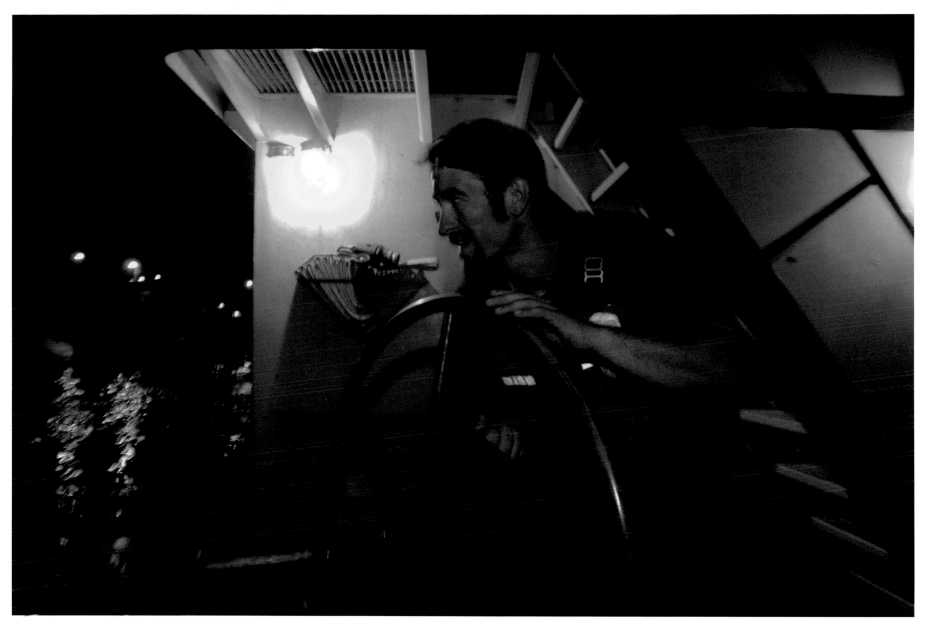

Deckhand Bill Beard turns a wheel to tighten cables
securing a barge to the towboat.

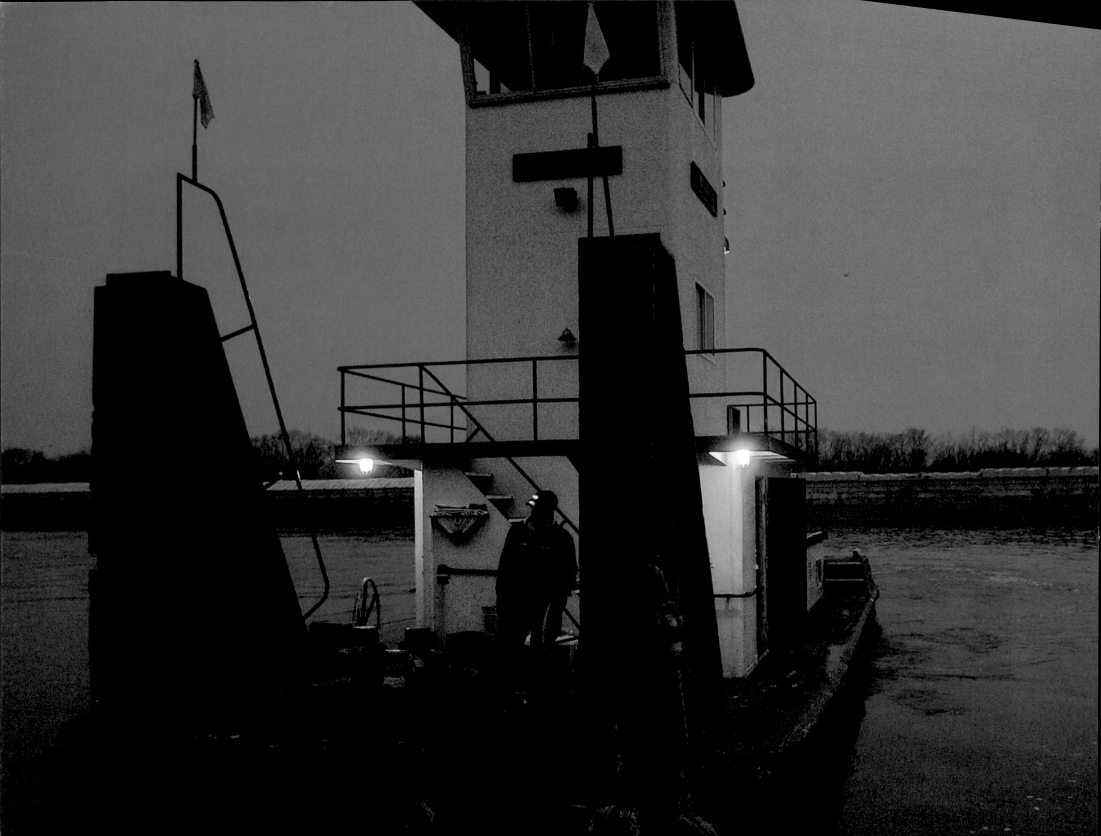

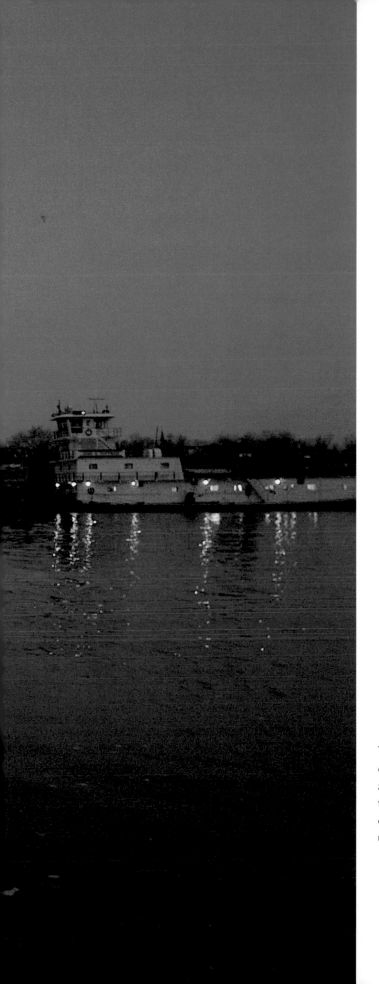

Trumbull River Service deckhand Bill Beard stands on the deck of the towboat *Niantic* as it backs away after securing a barge to a larger, southbound river tow. The river service shuttles barges dropped off or picked up by larger river tows after loading or unloading at Lacon-area grain terminals.

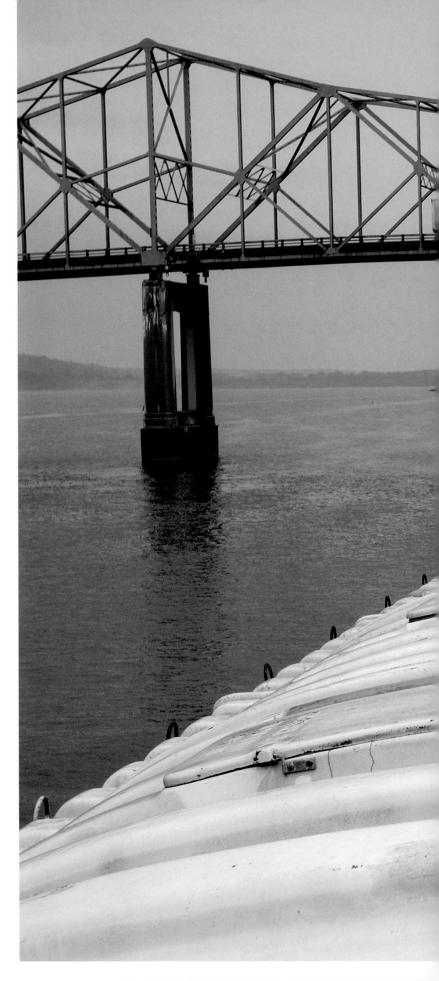

A lead barge heads toward the channel under the bridge spanning the Illinois River at Lacon.

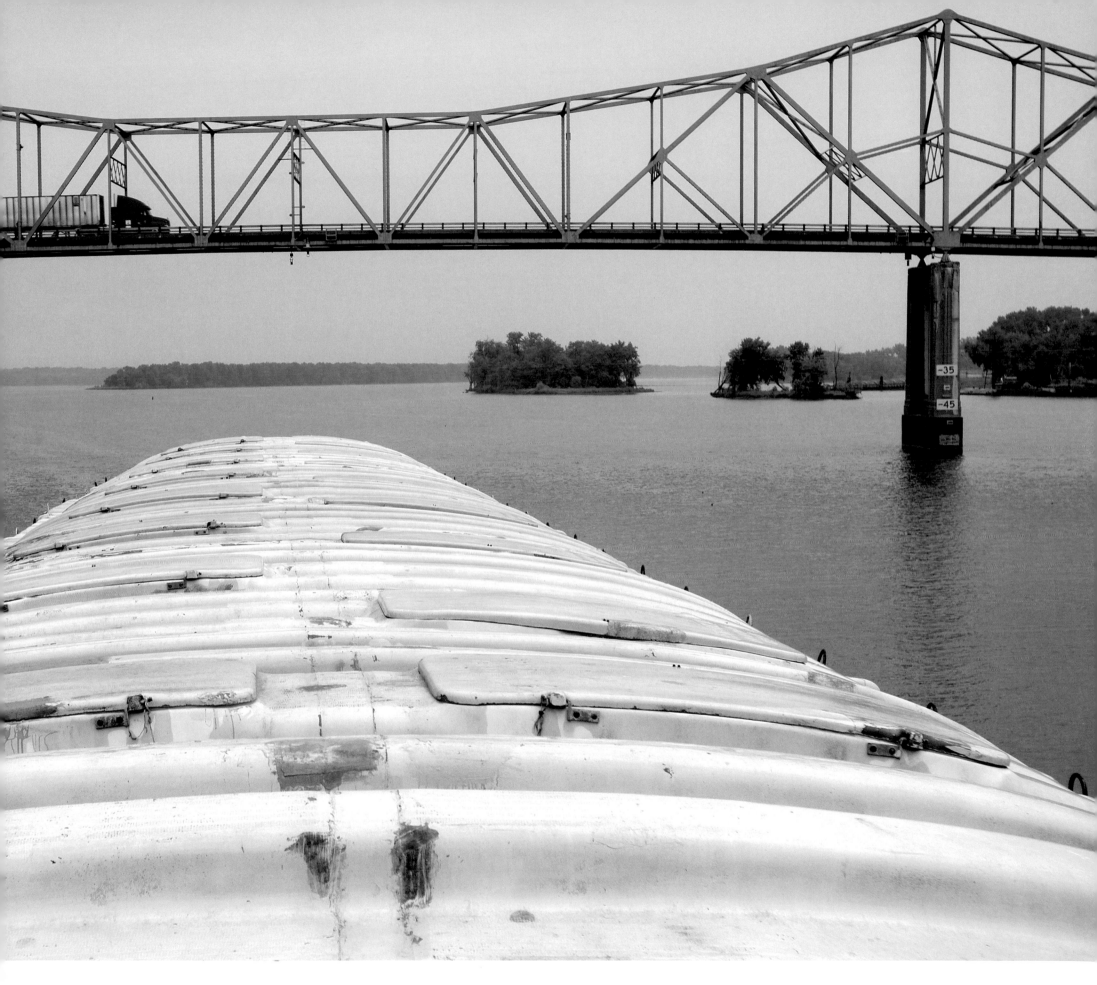

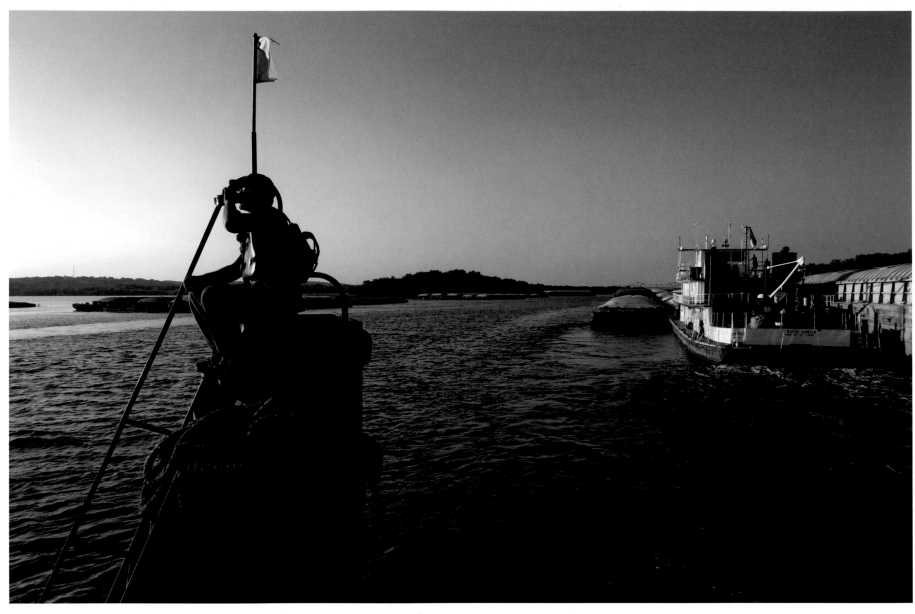

Bill Beard slakes his thirst as the Trumbull River Service tow approaches a larger river tow to retrieve a barge that will be placed in the Trumbull fleeting area. The barge will remain there until it is called for filling at an area grain terminal. Trumbull will shuttle the barge to the terminal, retrieve it once it's filled, and attach it to a southbound tow.

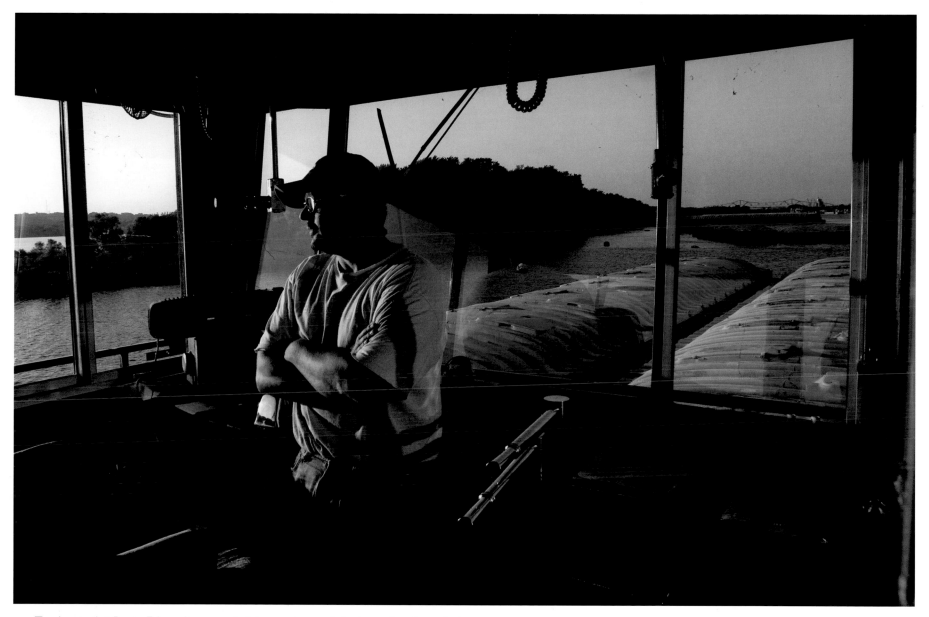

Towboat pilot Rusty Edwards pauses in late evening sunlight streaming through the pilothouse windows. He waits with loaded barges destined for a southbound tow.

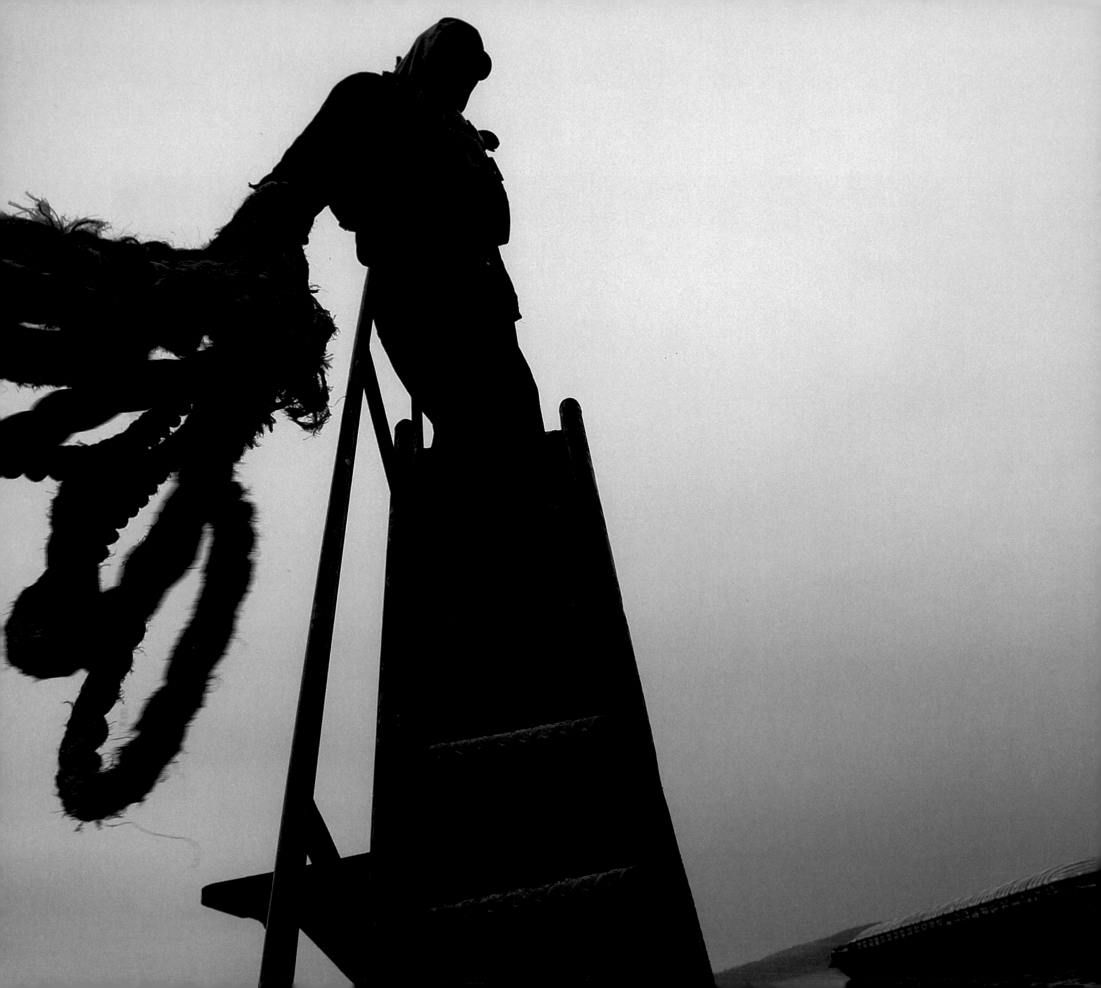

Deckhand Bill Beard works his ropes on
a gray December morning.

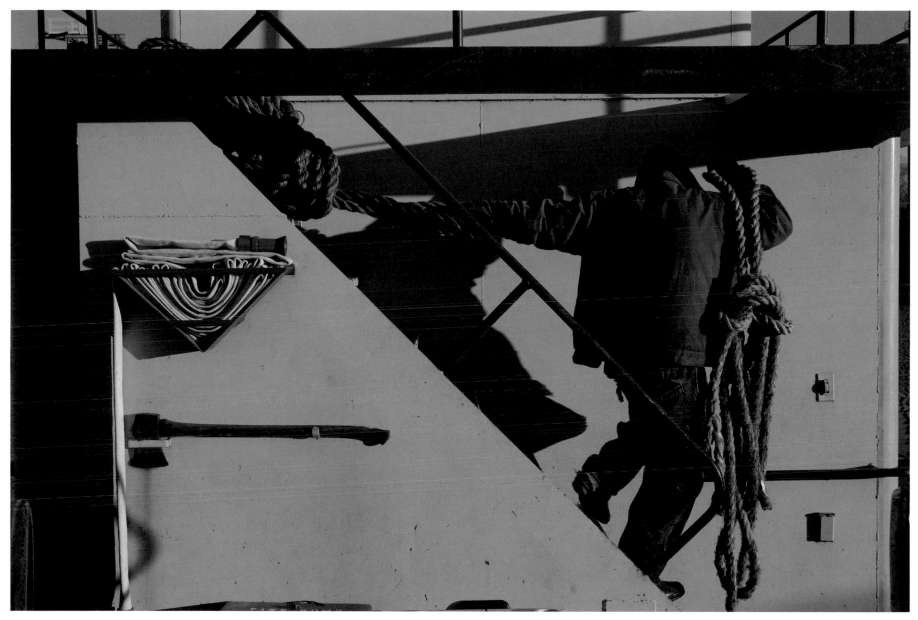

Towboat deckhand Bill Beard carries rope to position it
for use in securing barges to the tow.

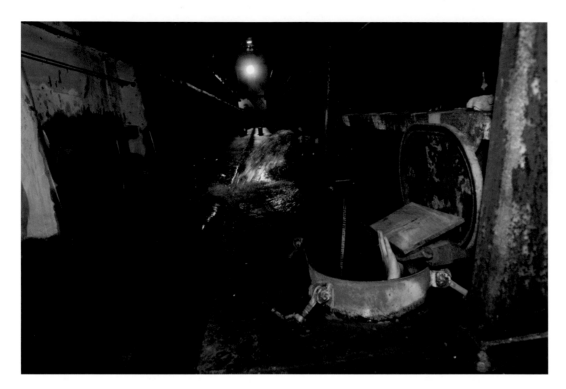

A hand reaches for a shingle from inside the hull of a barge. Bill Beard will use the cedar shake shingle as a temporary fix for a small leak. Forced into the opening in the hull, the shingle will swell with water and plug the hole.

Trumbull River Service,
Lacon, Illinois.

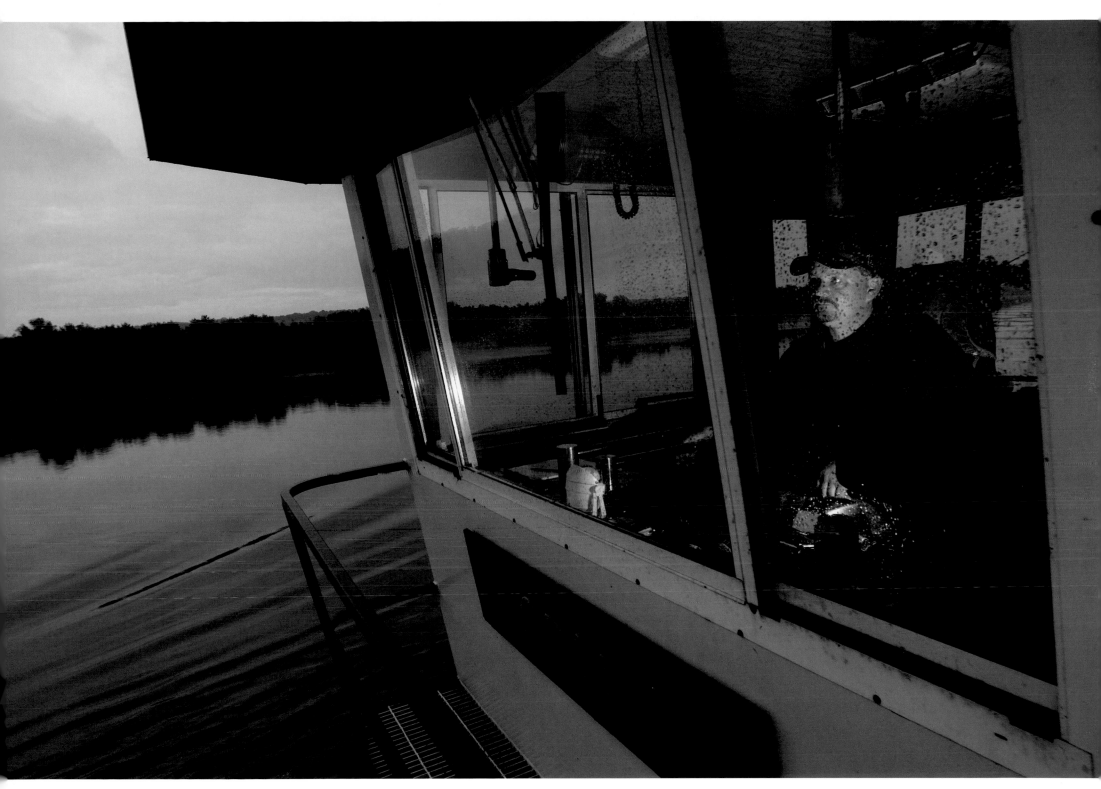

Towboat pilot Rusty Edwards steers the harbor tow *Opal* from Lacon
to Henry to retrieve a loaded barge from a grain terminal.

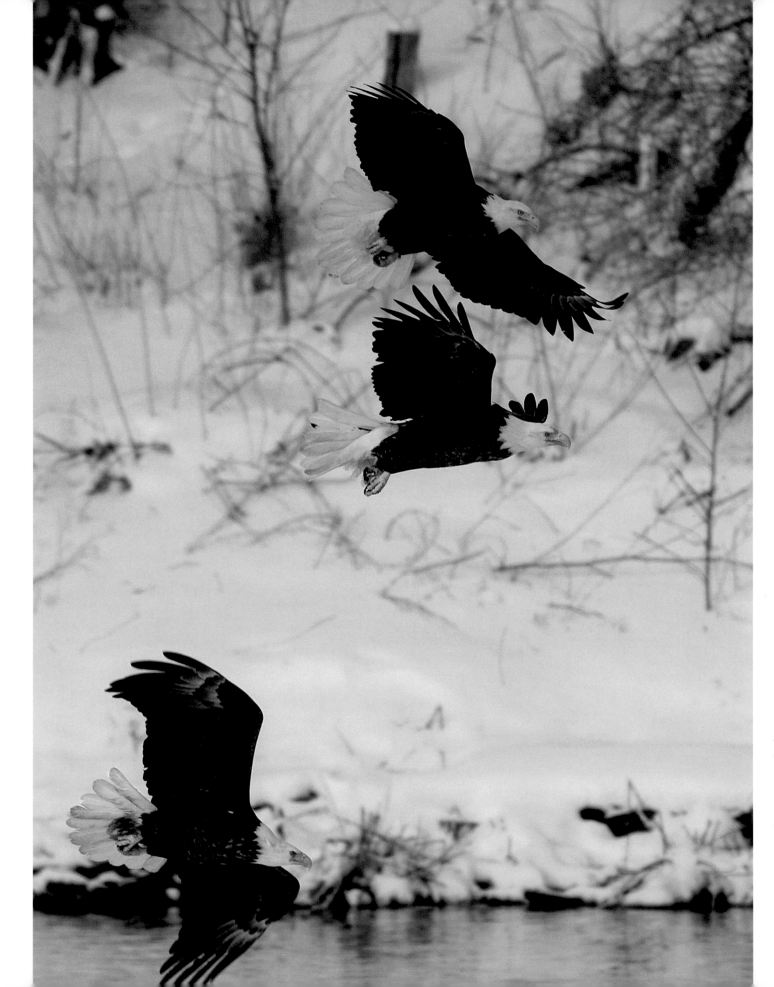

A trio of bald eagles flies over the open waters of Hamm's Holiday Harbor in Chillicothe where bubblers have kept the harbor free of ice when the rest of the river is frozen.

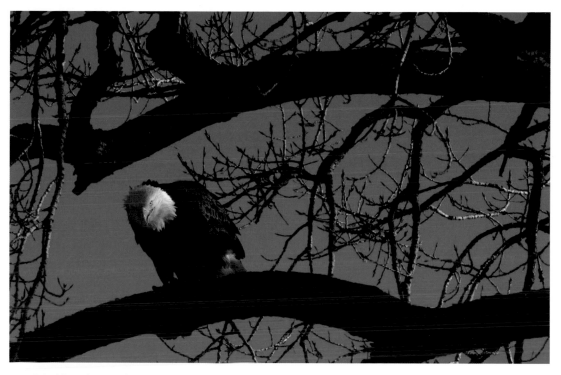

A bald eagle watches a visitor from its
perch above the Illinois River.

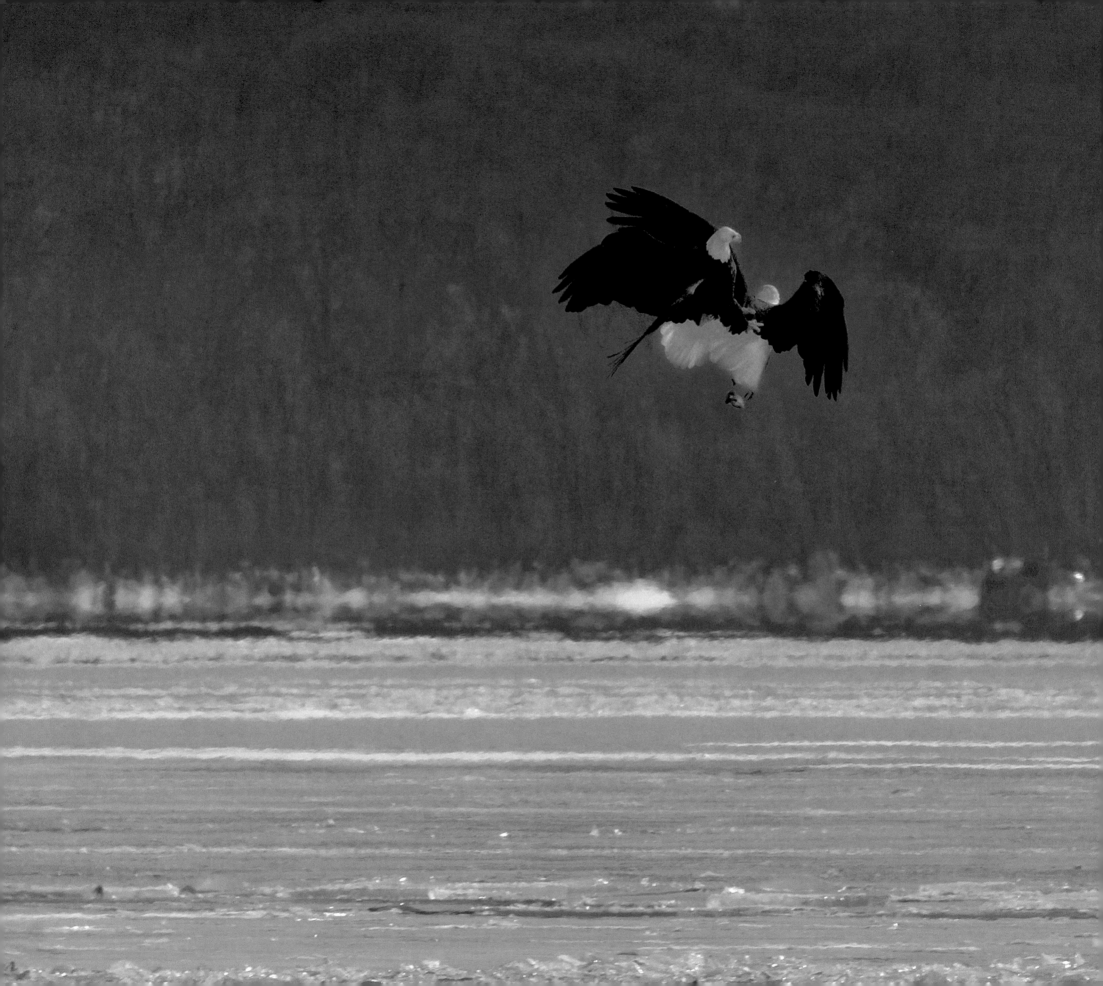

One bald eagle tries to force another to drop
its fish above the ice-covered Illinois River.

Overleaf: A bald eagle snatches a fish from a hole
in the ice covering much of the Illinois River.

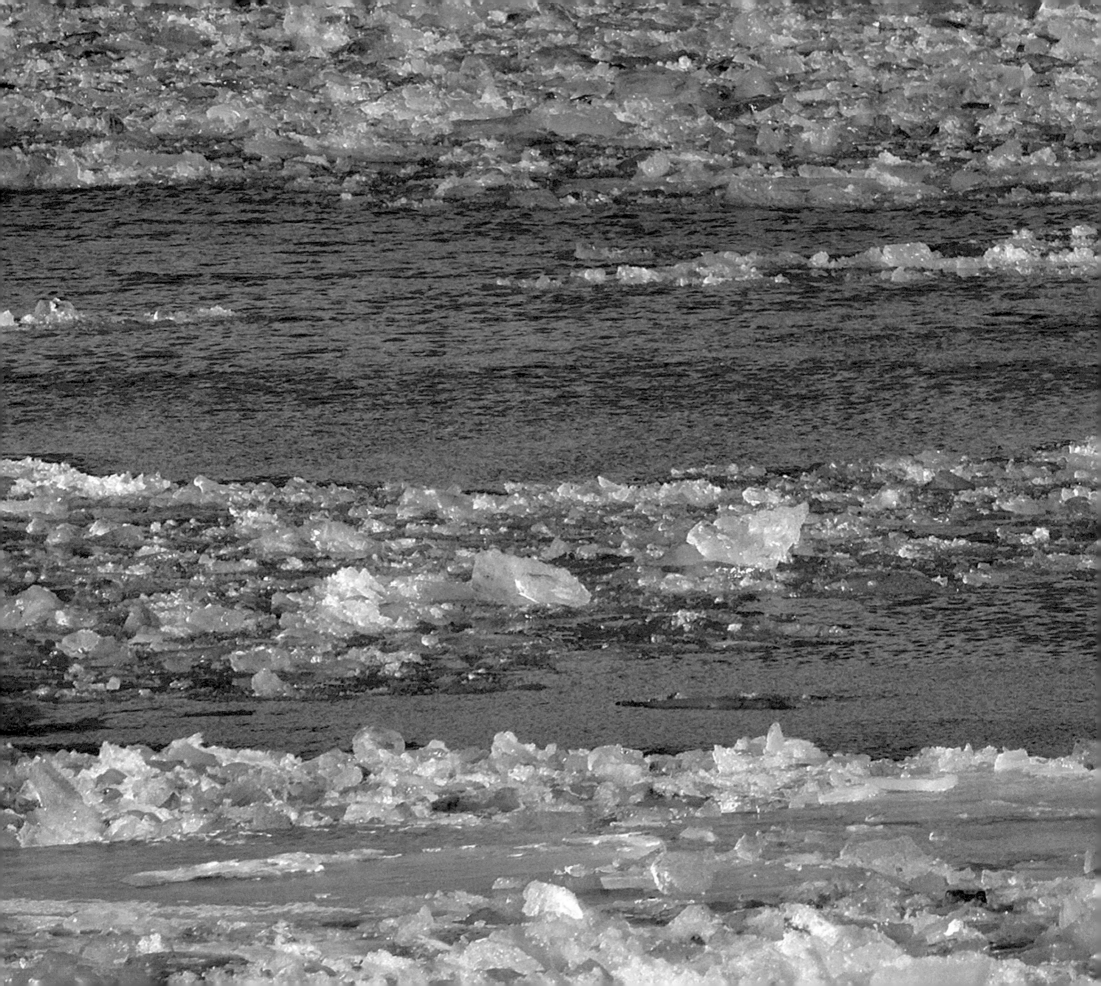

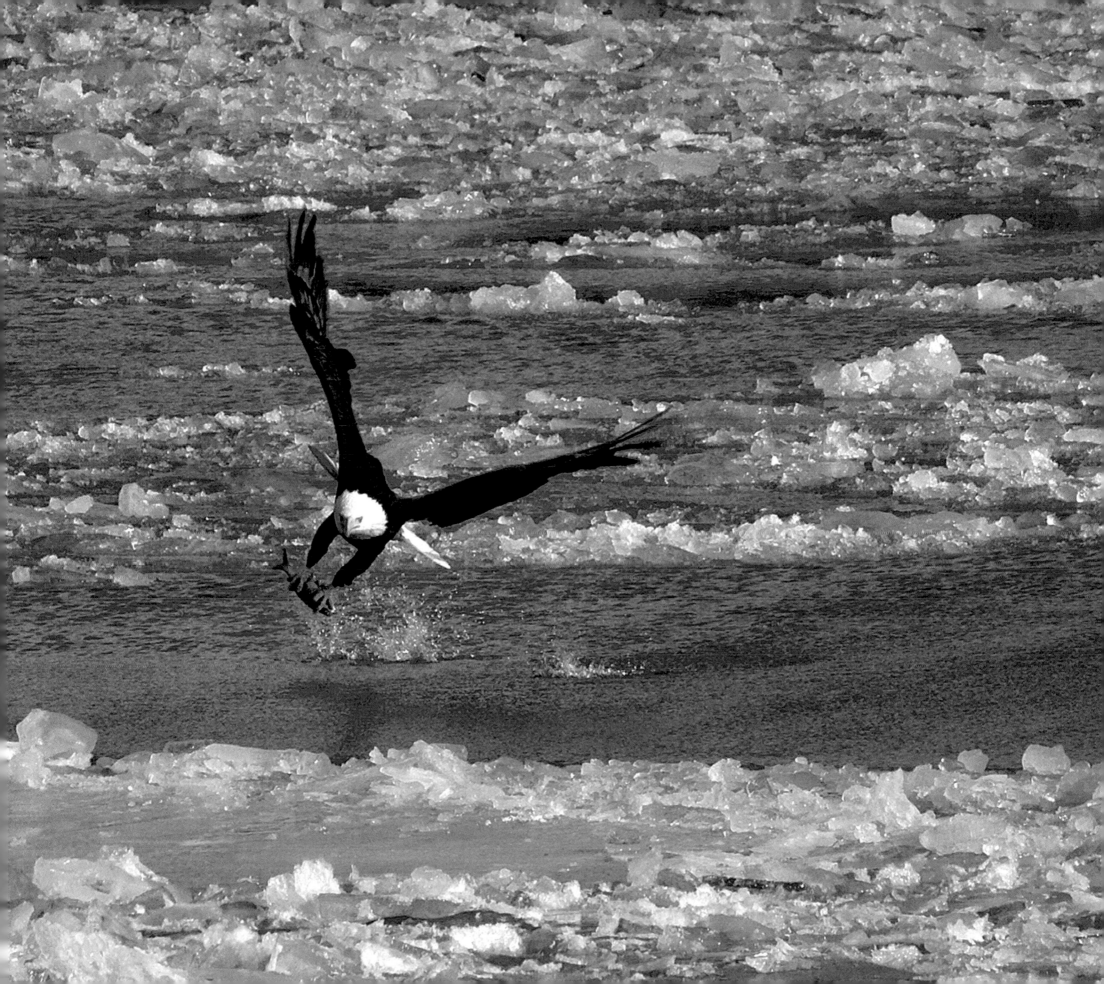

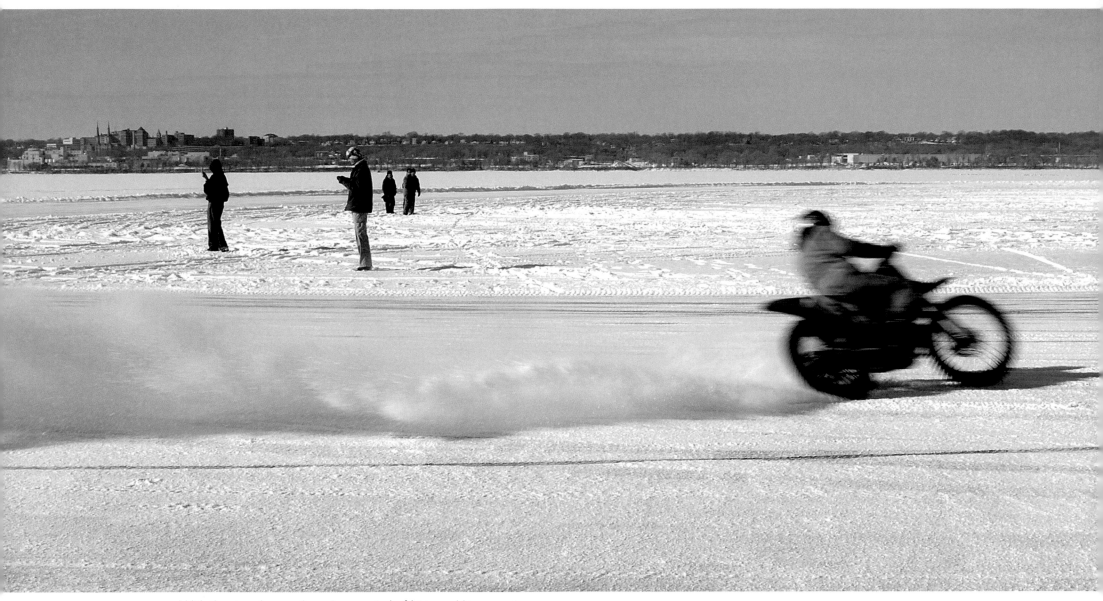

With the river frozen after a long period of bitter cold temperatures, motorcycle racers clear snow to form a track.

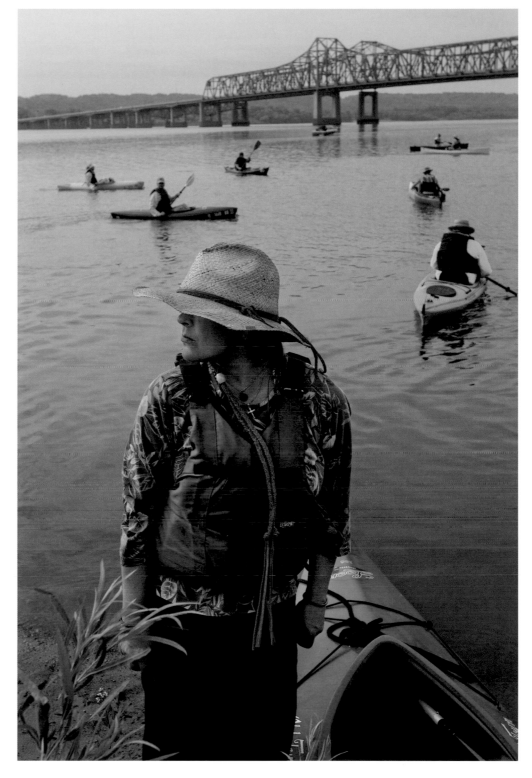

Carmen Mellott of Hudson, Illinois,
watches as Mackinaw River Canoe
Club members ready their canoes
and kayaks for a daylong trip on
the Illinois River near Peoria.

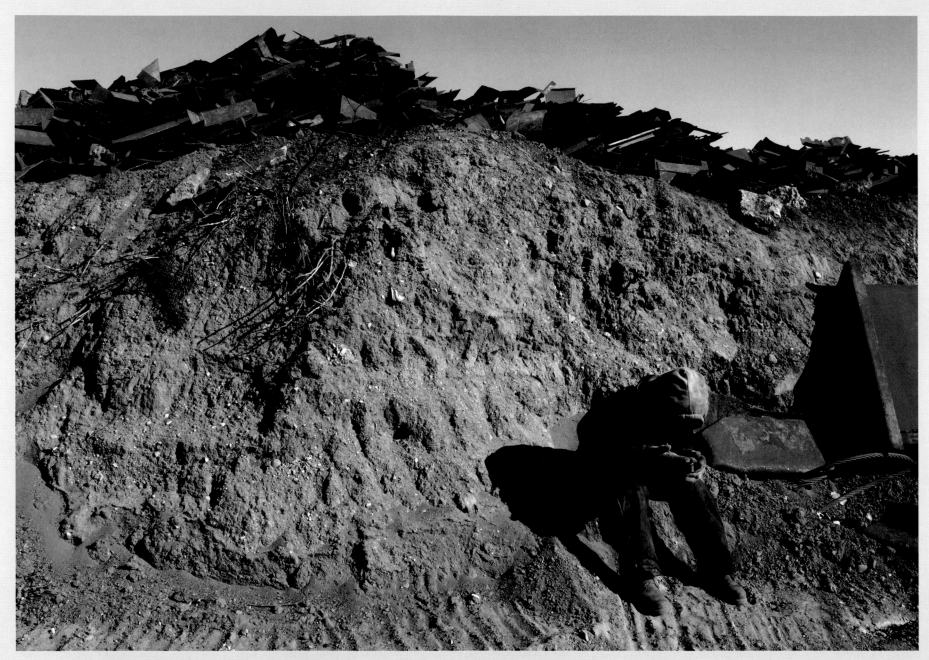

A worker takes a break from loading scrap steel cut
from a barge.

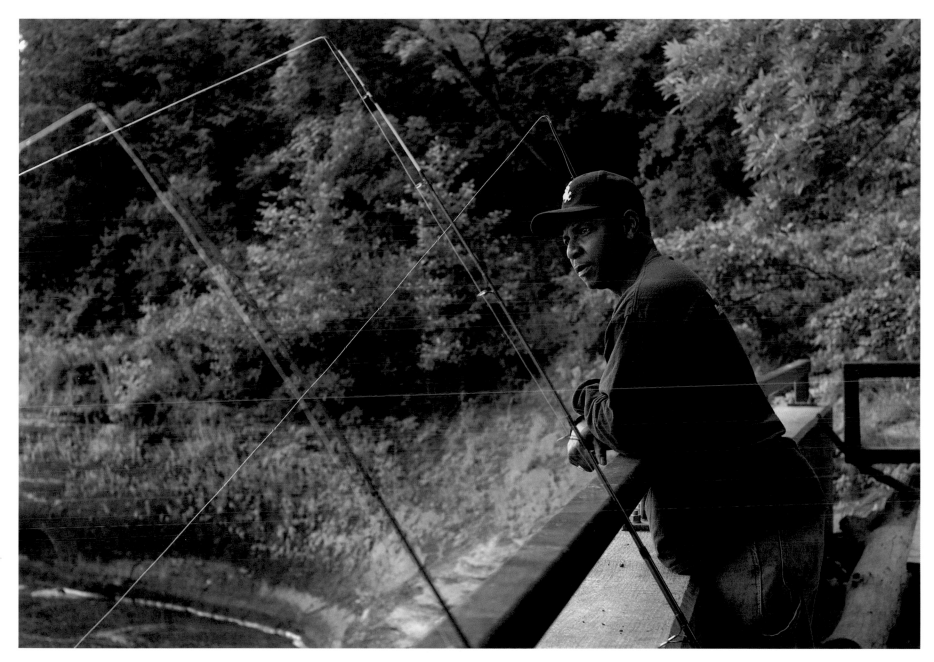

Schoolteacher Will Evans of Joliet keeps a keen eye on his lines
while fishing in the Illinois River at Starved Rock State Park.

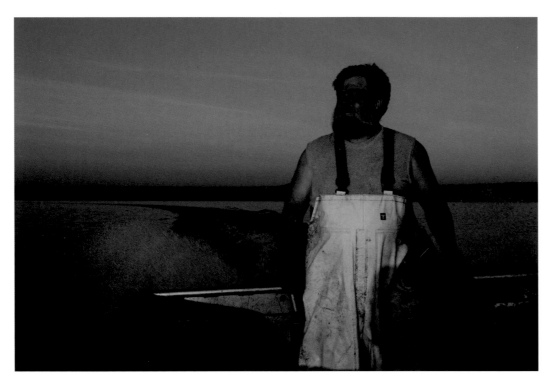

Sunlight strikes the face of commercial
fisherman Orion Briney of Browning.
Briney fishes for invasive Asian carp.

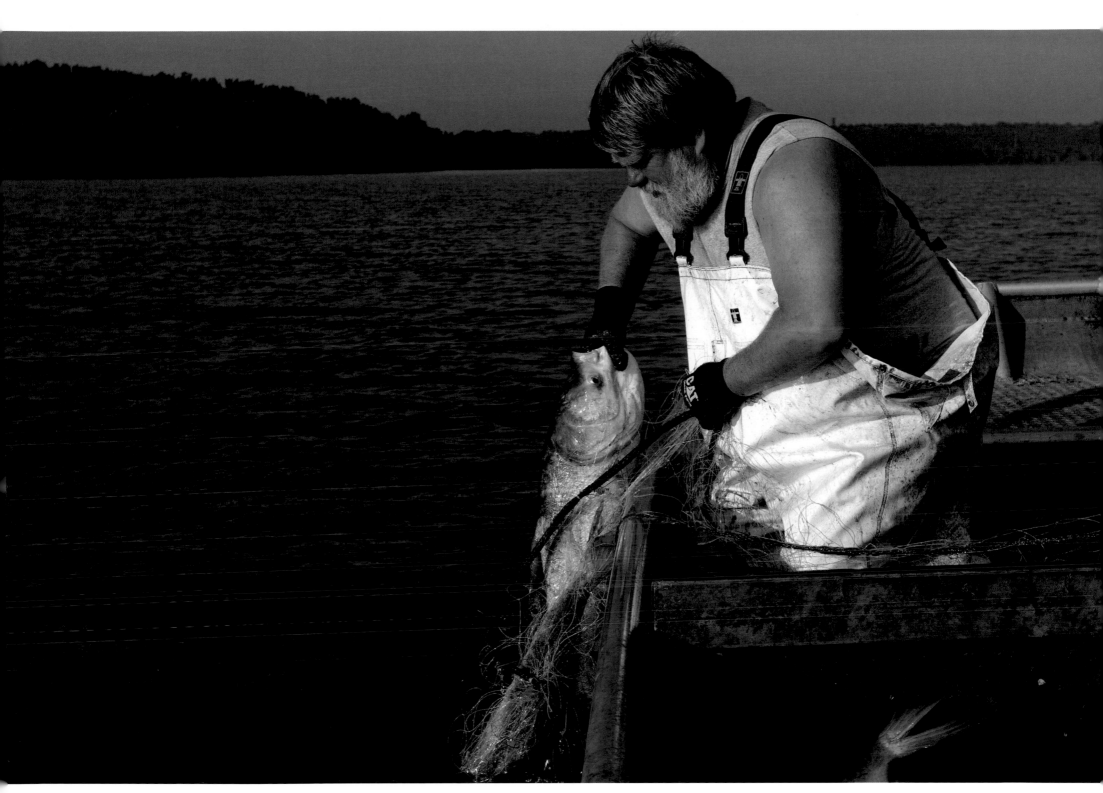

Orion Briney pulls an Asian carp from his trammel net. He and his crew harvested fifteen thousand pounds of big-head Asian carp in three hours.

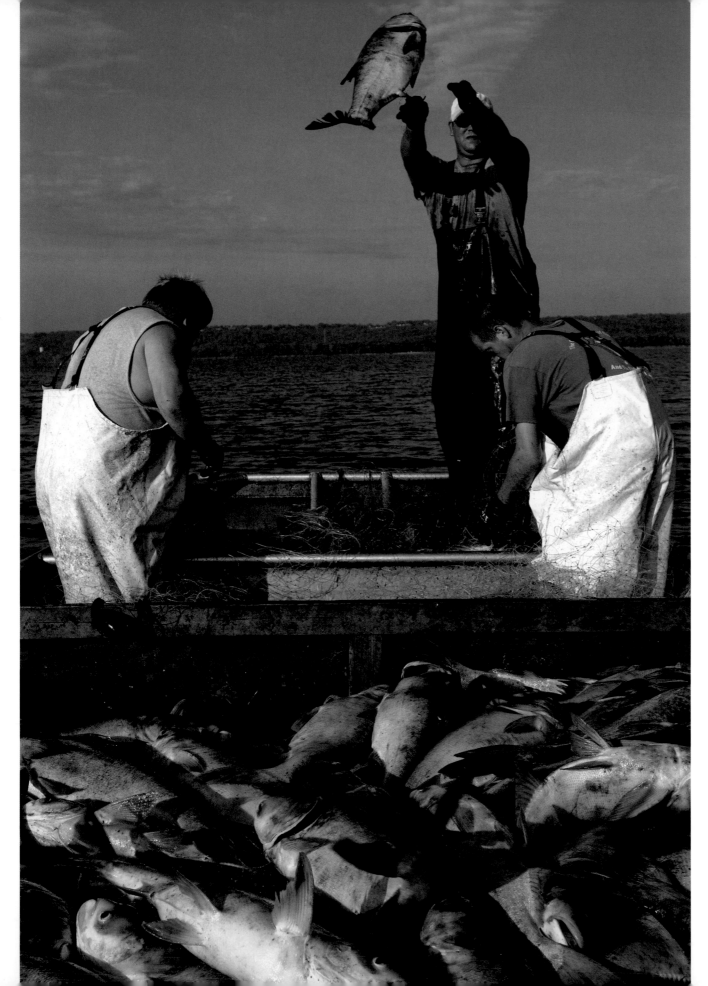

Matt Reed tosses an Asian carp to the center of the aluminum boat that Orion Briney, his step-son Jeremy Fisher, and Reed use in commercial fishing on the Illinois River.

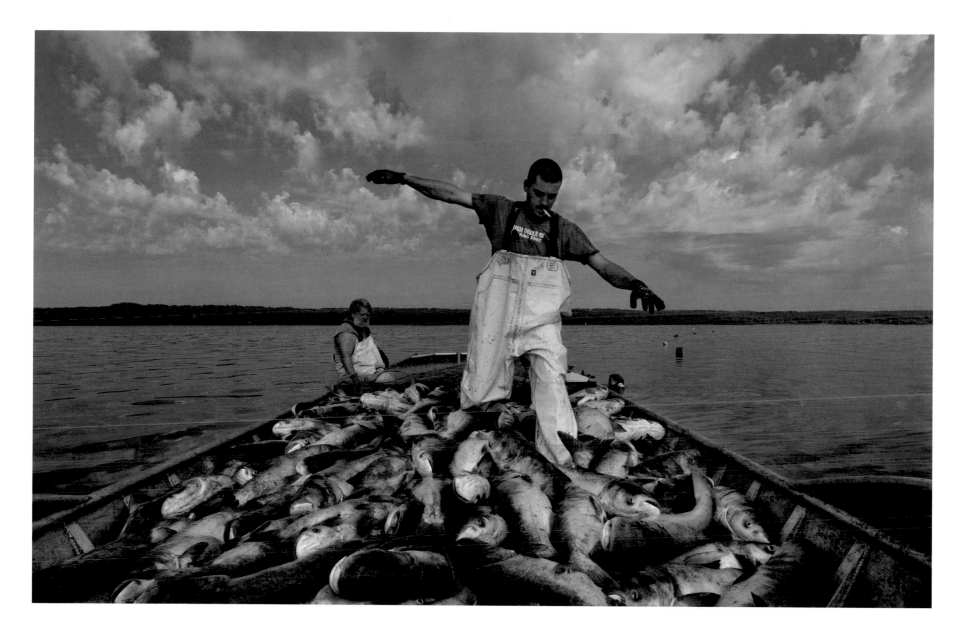

Jeremy Fisher steps through thousands of pounds of big-head Asian carp
that he and two others caught with trammel nets on the Illinois River.

A paddler joining an excursion with the Mackinaw River Canoe Club shoulders his end of a canoe to get it to the river's edge.

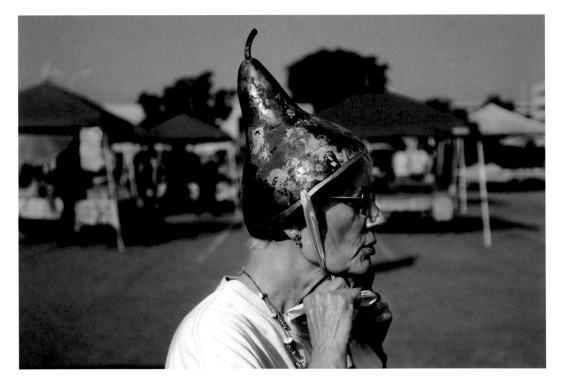

Left: Bonnie Cox dons her gourd headgear at the Peoria RiverFront Market, where she sells gourd art.

Opposite: Family and friends gather at the home of Michael "Doc" Higgins in Chillicothe to watch Fourth of July fireworks launched from Chillicothe Island in the Illinois River.

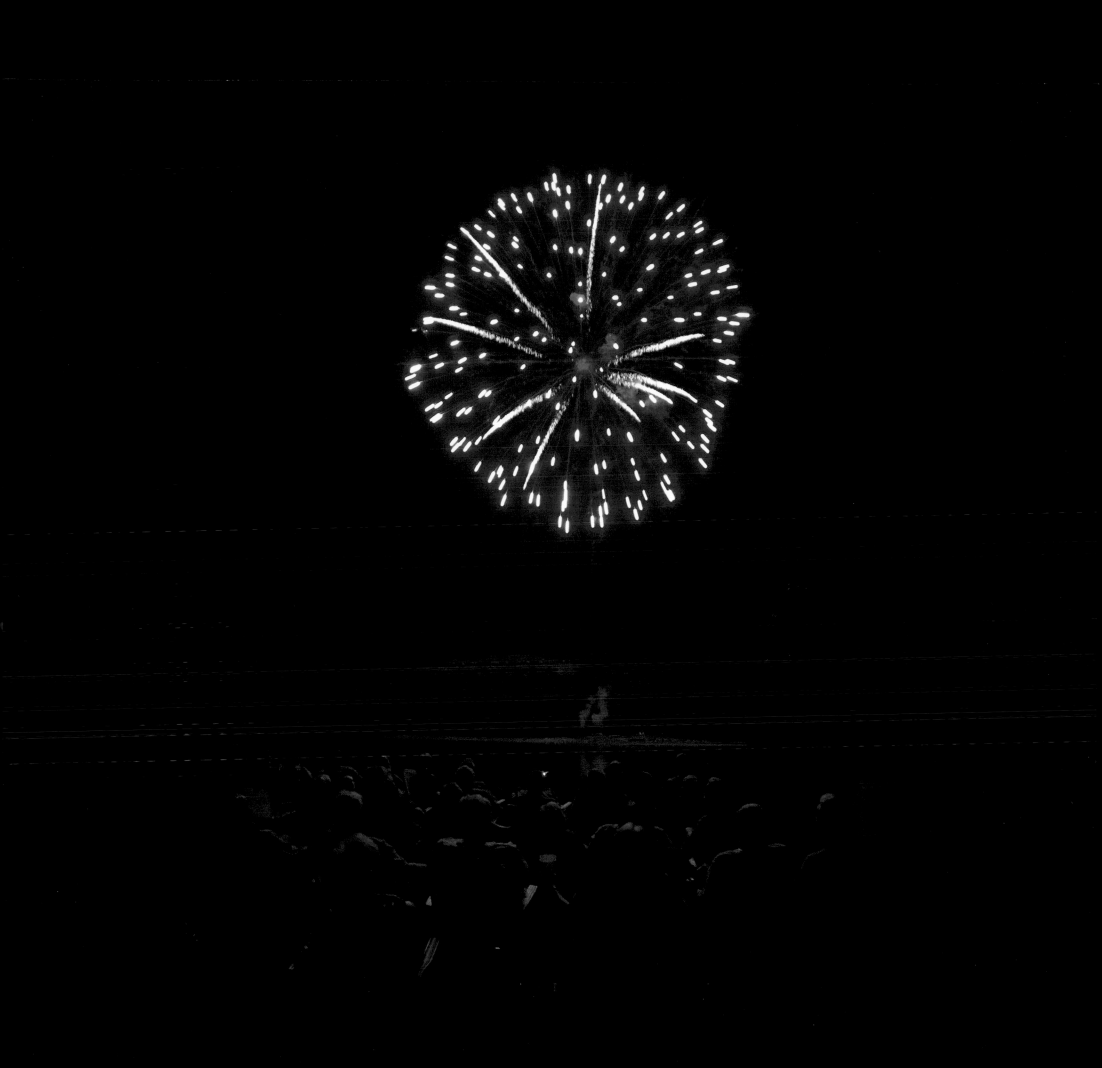

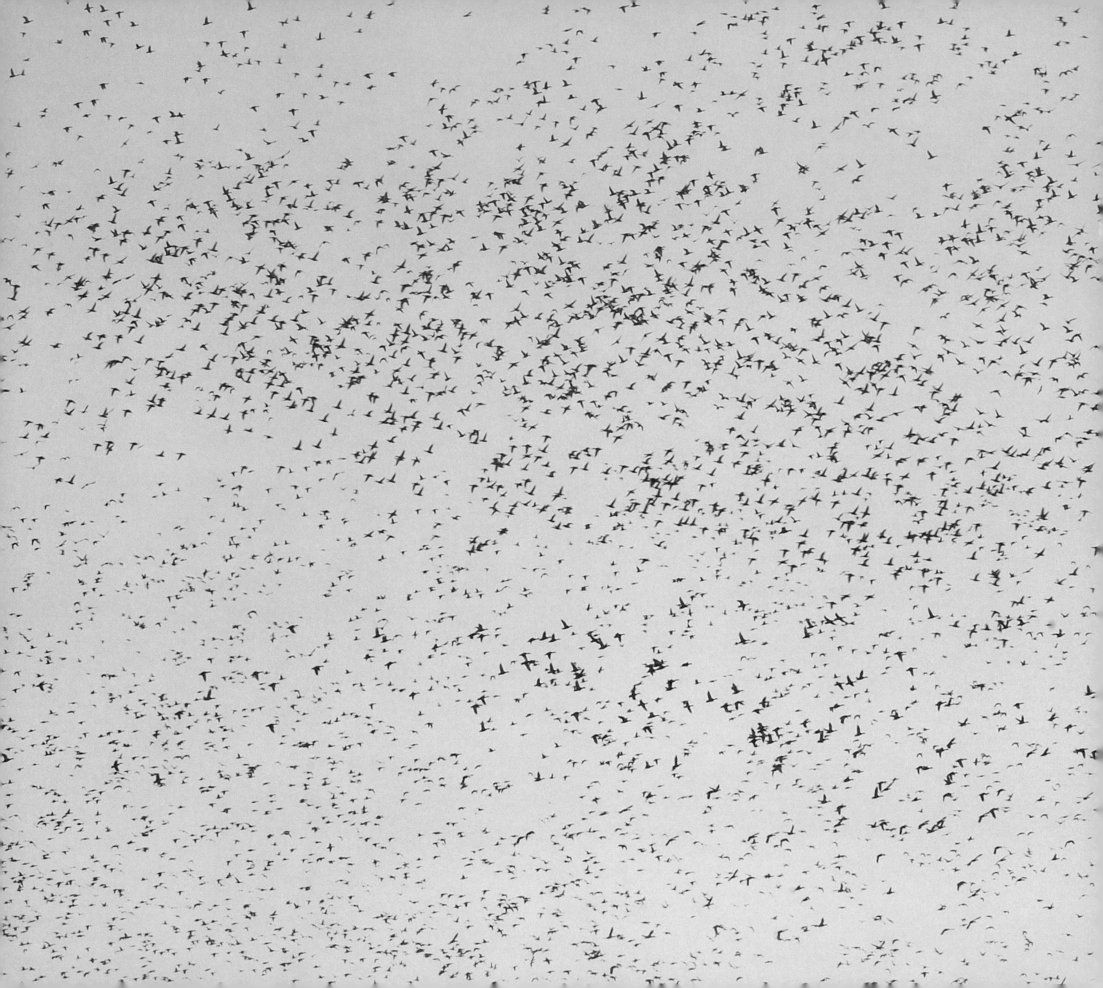

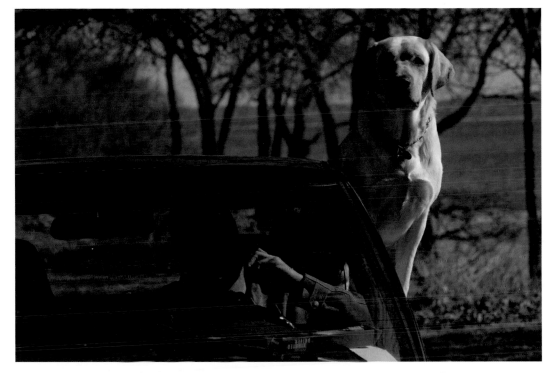

Ed Burd pauses for a phone call along the Illinois River as his dog checks out a visitor.

Overleaf: Ducks rise out of a flooded cornfield at a duck club in Woodford County.

A cloud of thousands of ducks disperses in all directions after flying out of a wetland in Woodford County.

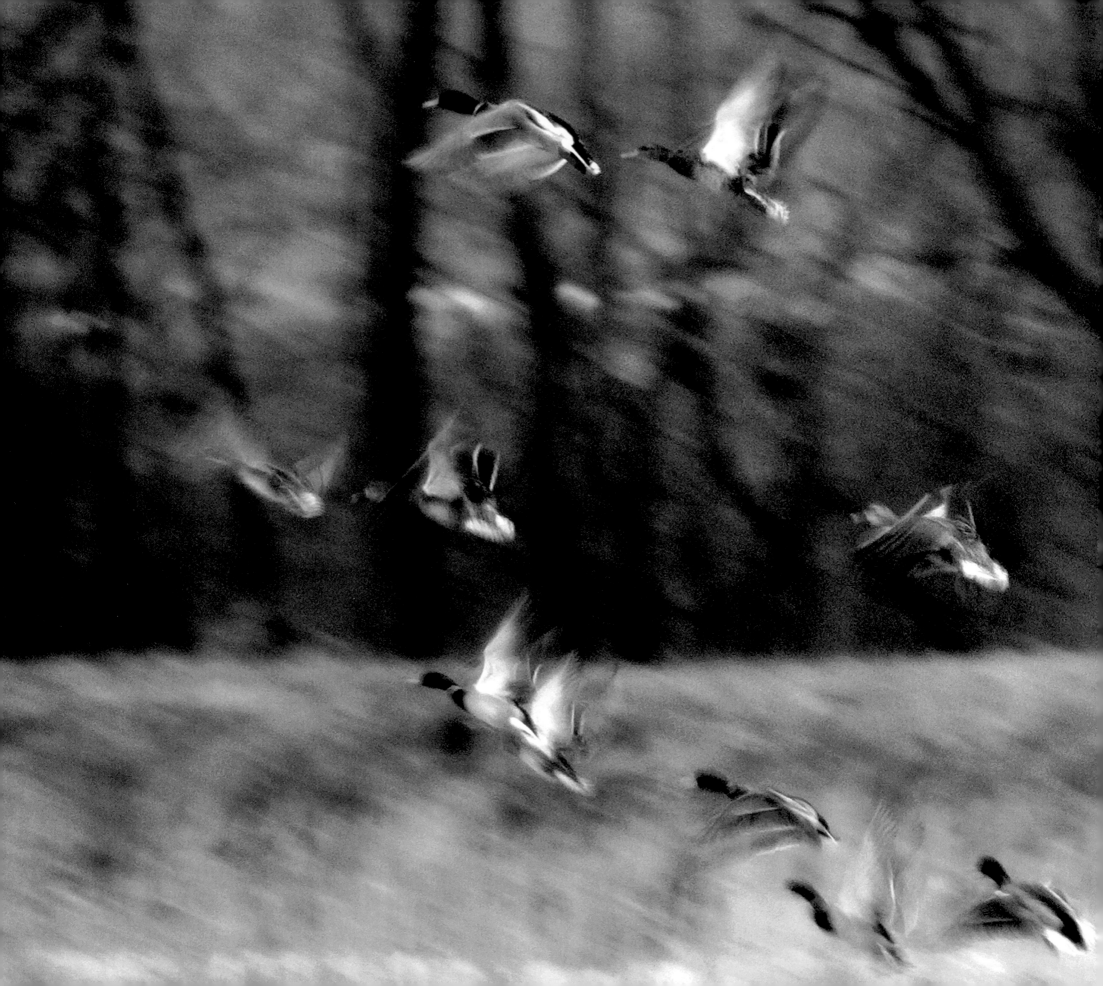

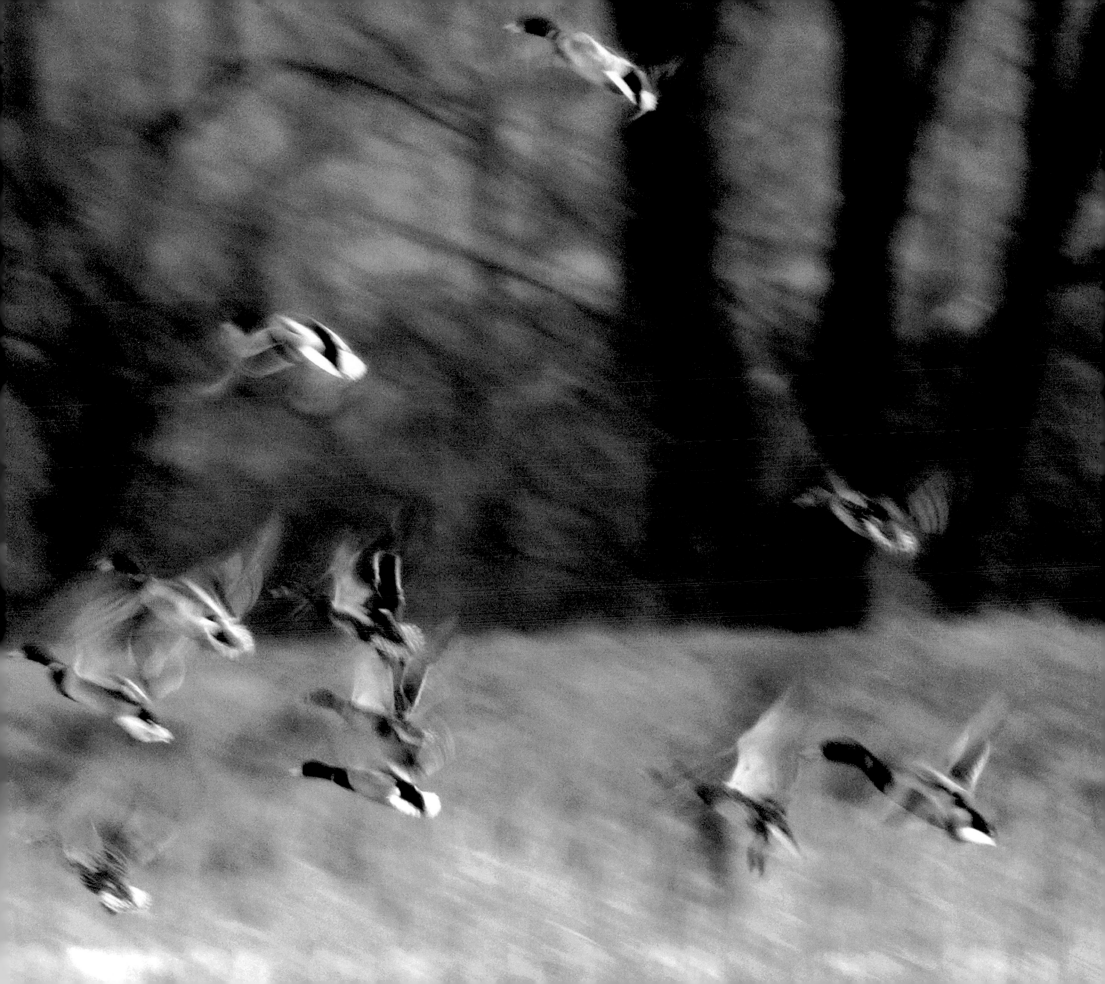

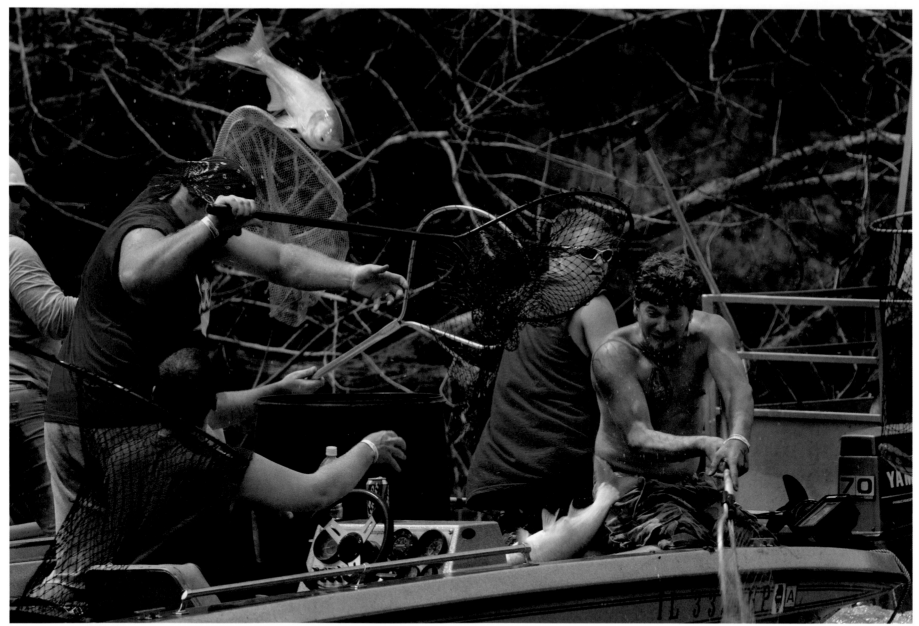

Redneck Fishing Derby contestant Craig Martin (left) dodges a flying silver Asian carp as David Connor (right) tries to snag another with a net. Adam Martin is in the background and Joe Hirkala is at the wheel of the boat. All of the men are from Streator and, along with Bob Bennington, made up the team "Pirates for Hire" at the tournament.

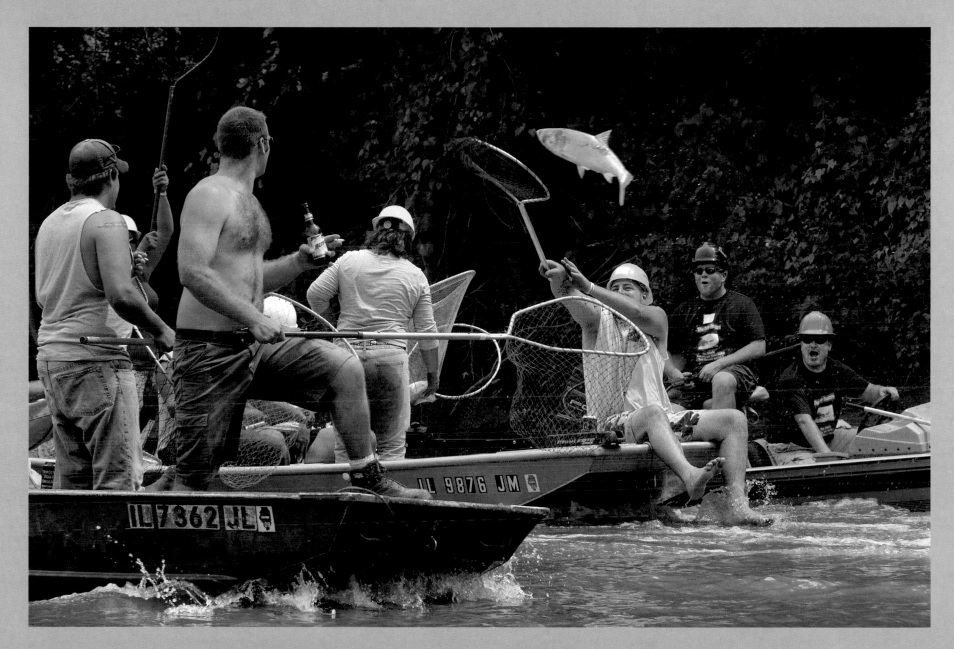

Contestants in the Redneck Fishing Derby in Bath try to snag a silver Asian carp from the air. Rules stipulate that the catch counts only if snared with the net or if the fish jumps into the boat.

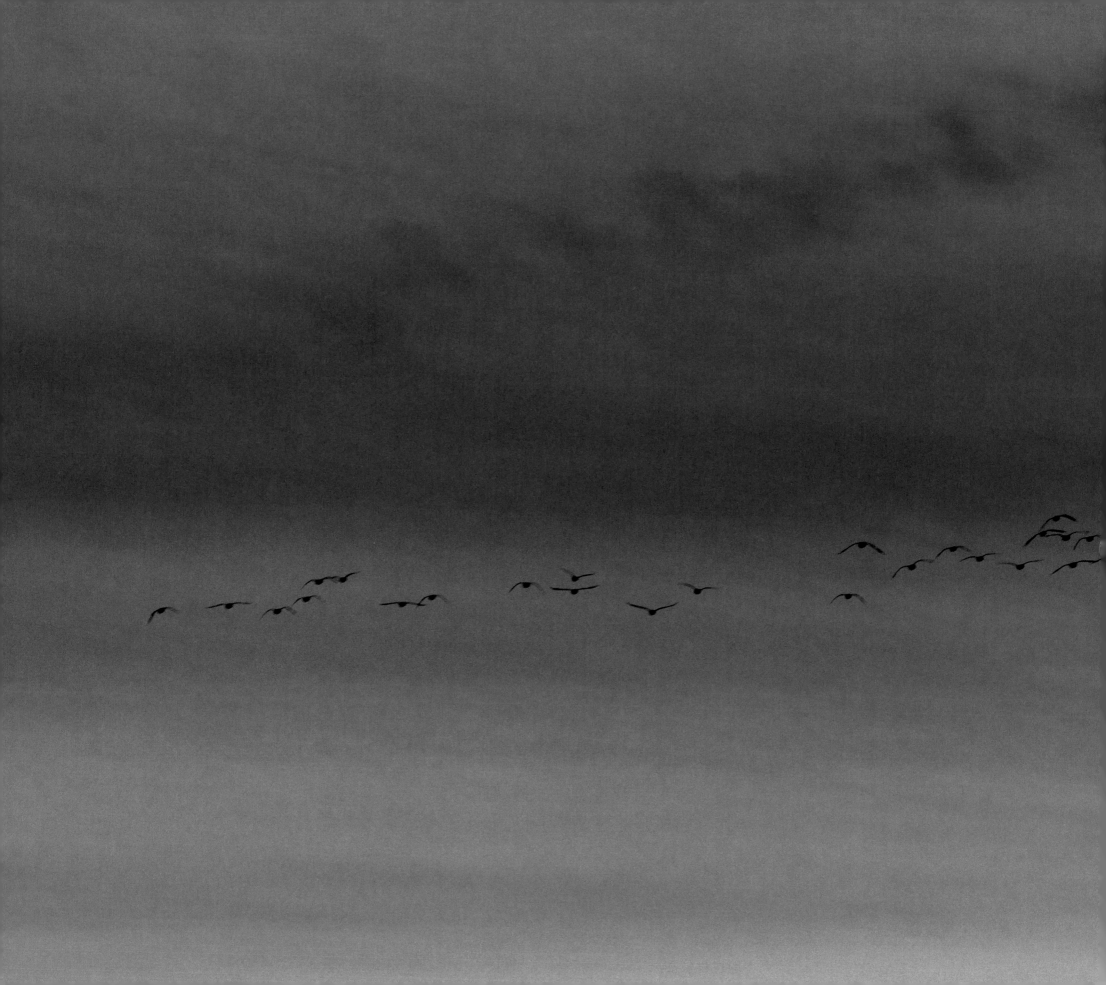

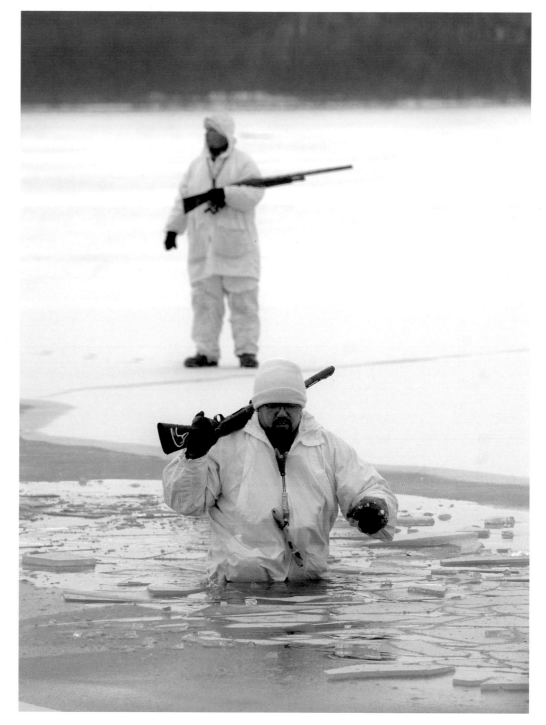

Rodd Bridgman wades through the icy waters of the Illinois River empty-handed after a morning of goose hunting. In the background is Bryan James, whose father, Verne L. James, hunted from a blind on the river's bank.

Canada geese wing into the darkening sky after sunset above the Illinois River.

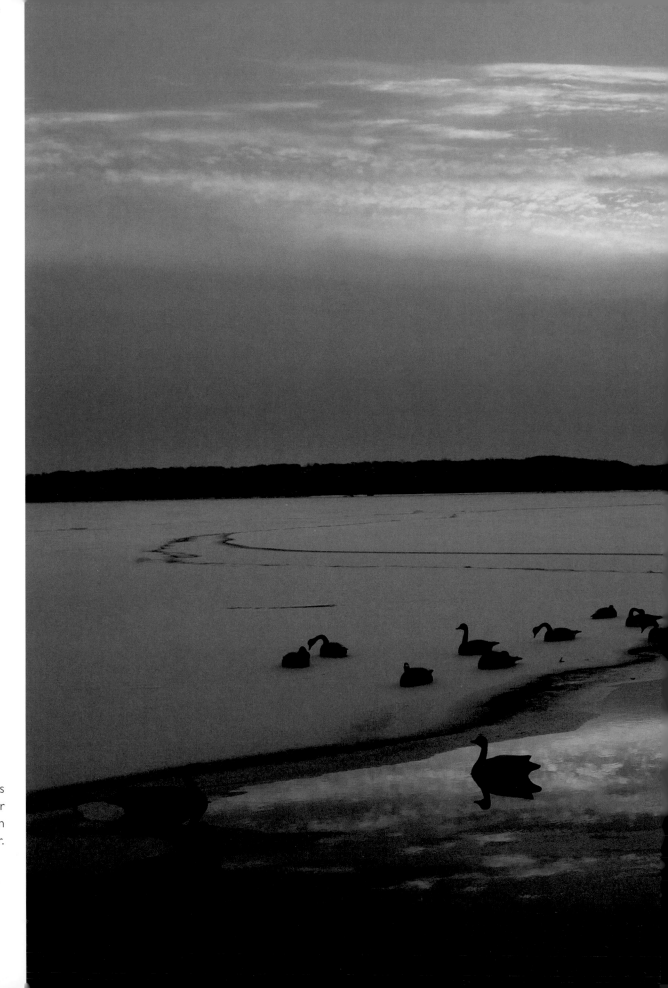

Rodd Bridgman and Bryan James stand on the frozen Illinois River as their goose decoys float in open water.

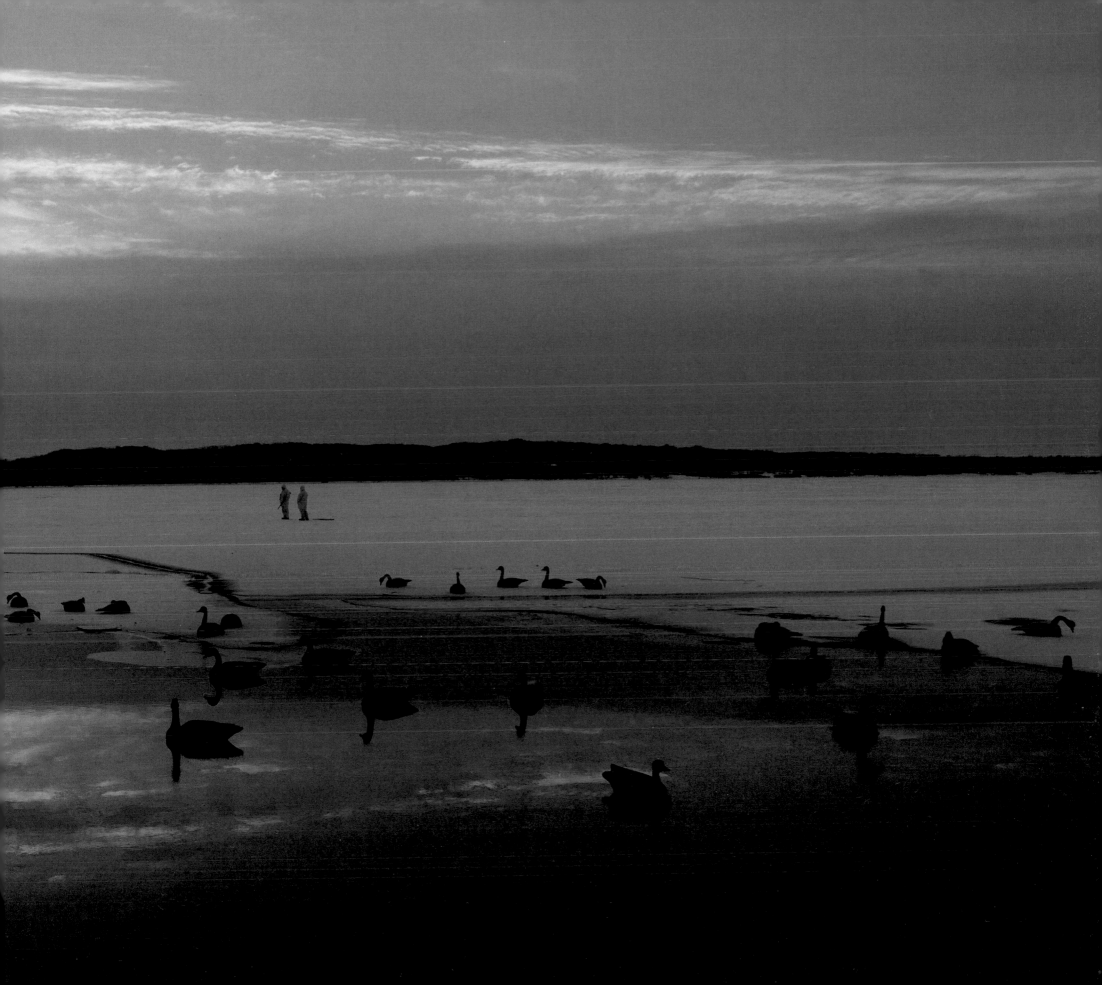

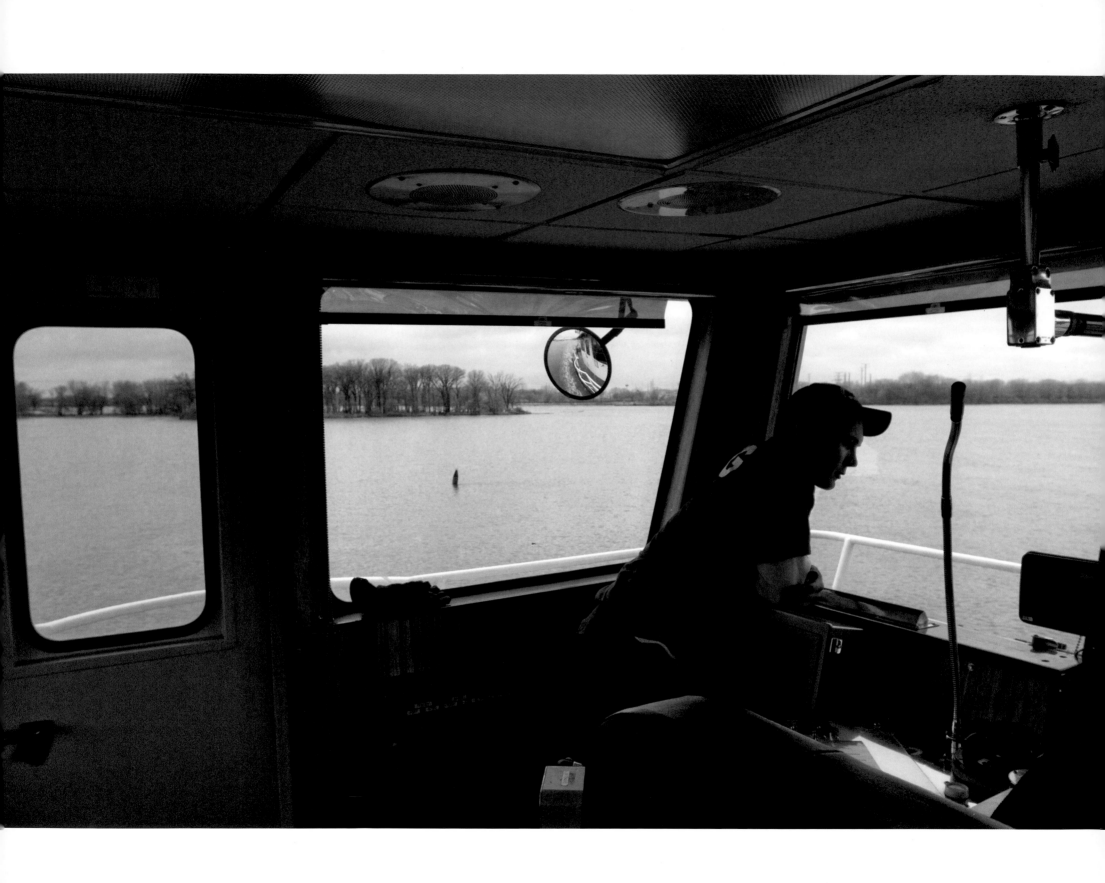

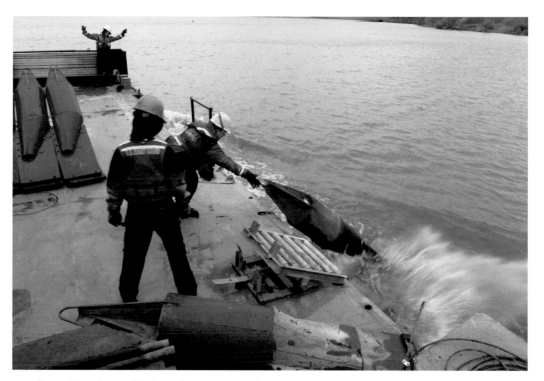

Coast Guardsman Zachary Stewart raises his arms to signal that the buoy is away as Coast Guardsmen Josh Lucio, pushing the buoy, and Stephen Polley, foreground, drop channel markers from the Coast Guard vessel *Sangamon* to mark the navigation channel in the Illinois River.

Coast Guardsman Chase Sibley leans on a window in the pilothouse of the Coast Guard buoy tender *Sangamon*. In the background, the Des Plaines River, at left, joins the Kankakee River, at right, to form the Illinois River near Morris.

The Illinois River reflects
the pastel colors of dawn.